À Valérie

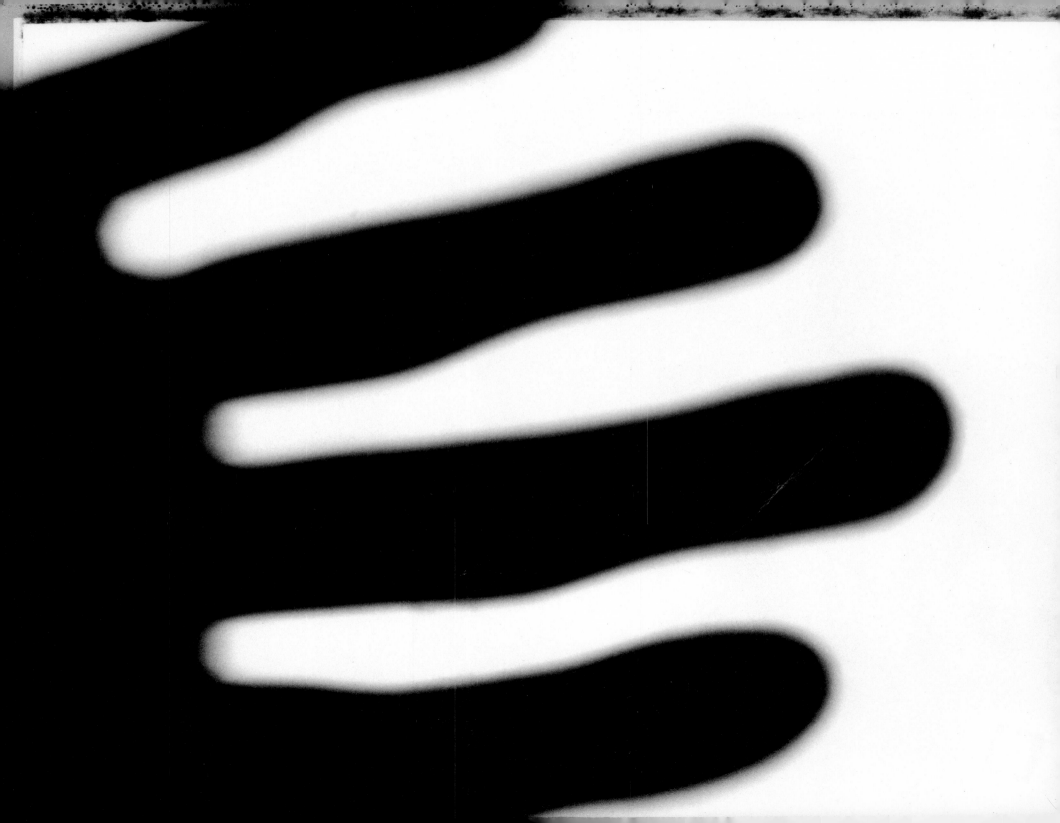

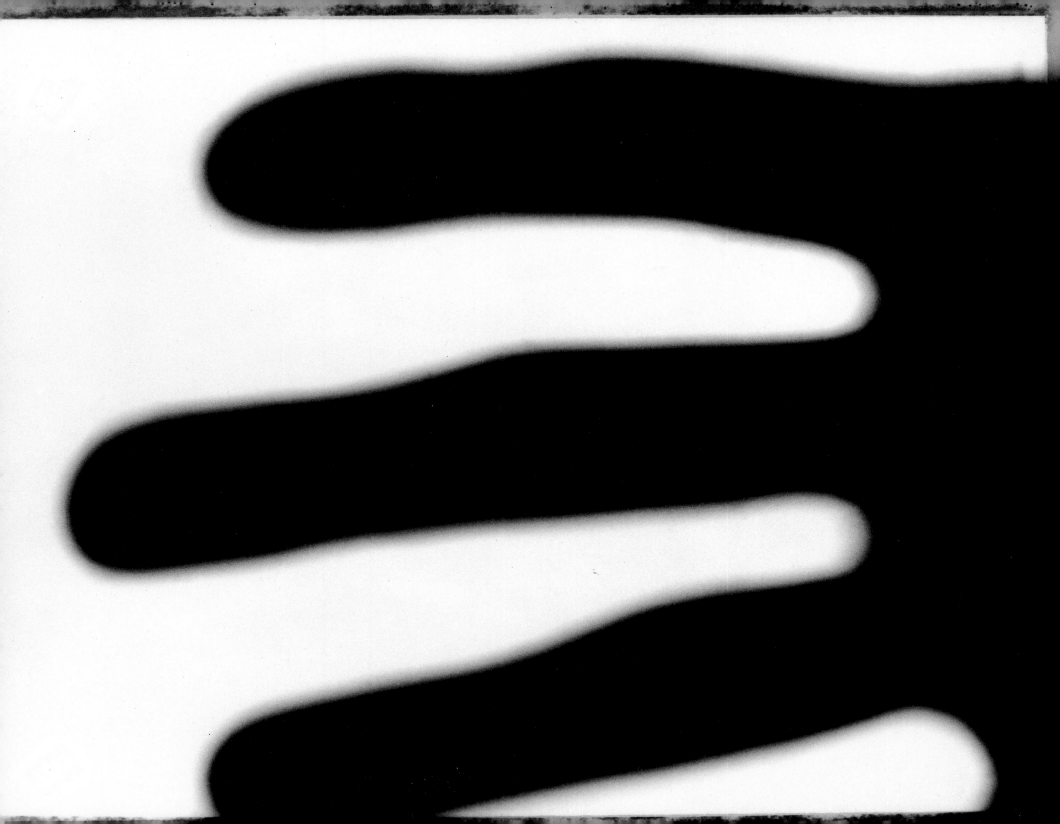

Olivier Christinat
Apocrypha

fotofolio

A Theologian's Point of View Bernard Reymond

Apocrypha: the word is well chosen. Christian tradition distinguishes between two categories of scripture. The so-called biblical "Canon" includes the Old and New Testament, recognized by the Christian Churches as rule of faith. Clearly, this is the most well-known body of texts. However, there are other writings, for example the Gospel of Thomas, that are not included in the Canon, even though they share, more or less, the same subject. These texts are the Apocrypha. Strict Orthodoxy tends to be wary of it. But what would Christianity be without its heretics, that is, without those who question accepted norms and convictions, forcing people to hurl themselves into uncharted inquiries? Heretics and the writers of

the Apocrypha do a service to Christians, and to many others, tearing them from their passive responses, arousing in them the healthy concern for how to make, imagine, consider and live the future. Only fifty or a hundred years ago a theologian would probably have been rather surprised by Olivier Christinat's images: they make obvious reference to the Bible, even though nudes play such a large role. This theologian would have been shocked about what he would have considered a lack of modesty, and – assuming that he would even look at them – the nudity would have seemed the essence of the Apocryphal nature of these images. He would have seen eroticism where it does not exist, at least not in the sense of

pathological and exhibitionistic immodesty. At the same time, he would have completely missed precisely what these photographs offer. Modesty, like beauty, is a social convention. The nineteenth century, as we all know, was one of the most prudish times of the Christian era, and our theologian of fifty or hundred years ago, even of protestant and liberal convictions, tended to support the Pope who decided to clothe or drape the many nudes, including the Virgin, in Michelangelo's *Last Judgement* in the Sistine Chapel. Some might take offense at Christinat's images; others might be astonished by, or even indignant at the thought that Cardinals have to elect a new Pope beneath the nude figures of the Sistine Chapel

(even if the very recent restoration of this fresco had to abandon the recapturing of all the original nudity). But this very freedom of reaction implies another: the artist's. With the very title of his book, Olivier Christinat joins the tradition of Apocrypha writers, literally those who "are hiding" something. In fact, it is the tradition of those who, on the contrary, sought to reveal aspects that were being kept hidden. "Hide that breast that I cannot see" (*Tartuffe*). I do not think that it is wrong to see in Christinat's photographs, consciously or not, the need to overturn the protective clothing codes which involve everything that is linked to Christian tradition, in order to clear the way for the questions, intuitions, mental or emotional associations that these images suggest. But what are these questions, these intuitions, these thoughts expressed in Christinat's images? Must the theologian feel obliged to say what he means, even to suggest a "theological interpretation?" Rushing to judgement, he would be more than likely to misunderstand these images, without really seeing them for what they are. And from here it is only a quick, short step to taking them for what they are not. The pitfall to avoid, I think, would be to see these photos as illustrations of biblical episodes. Christinat, it should be noted, has not matched his images with quotations from Jewish or Christian scriptures – and this is something he could have done. For him, it was enough to make simple references to figures or stories he considered to be familiar (anyone who does not know them, or has forgotten them, can quickly find them again). However, he does not illustrate them in the sense of visualizing a certain passage in the Bible. Rather, he places us before the mysteries that these figures or stories suggest. Who are they really? Should we not see them in a different light than the perspective offered by tradition? Where is their mystery? What is their relationship to their own corporeal nature or destiny? And if we are not sure how to understand simple titles like *Adam and Eve* or *Lot's Wife*, we can read them in the light of more descriptive titles: *God Disturbed by His Own Image, That Which Can Be*

Defined, Before Heaven's Silence, or God at a Loss to Know How to Use His Power. In other words, Christinat does not provide us with explicit captions to help us better understand the message of the biblical texts, nor does he inform us about their subject. He, rather, offers images as a counterpoint to those instinctive images that usually come to mind for anyone familiar with western Christian tradition. This said, how could I interpret this series of images, or each image separately? I haven't even finished looking at them. And what I might say right now, especially in a context as permanent as written discourse, would only constrict the freedom of imagination for those looking at them. Christinat's photographs seem very clearly to fall into the category of works that Umberto Eco calls "open." That is, they do not impose a fixed meaning, but rather open the way to imagination and, in this case, to contemplation.

In the same way, this book is open to many viewers. I would think that those Christians linked to biblical tradition would have very mixed feelings; they may have to come back twice, perhaps even three or four times, to begin to seize the paradigm that some of the images suggest. Sometimes I can see they may have doubts in their minds. For example, they might question the role of God's omnipotence, or even whether this omnipotence exists. Others, who are "every other day believers," as one French Protestant recently considered himself, may feel that they understand these images, for they too ask questions. They too are not among those who we, perhaps wrongly, consider to have "unshakable" faith. And then there are the agnostics, whose agnosticism might vacillate before some of these images. Or they could wonder how someone like Christinat can continue to allow himself to be haunted by so many reminders of the presence or absence of God. And as for the esthetes, will they be able to stick to the strict formal viewpoint, or to the existential precautions they normally adopt? It is not my place to choose or decide for them. My theological choice, as I stand before these photographs, is therefore to

avoid all introductory discourse or commentary that would seek to speak for the images, or limit the multiple interpretations that they open or suggest by projecting almost superficial meanings onto them. In any case, in a book like this one, one will look at the pictures, perhaps quickly, well before reading the accompanying text. Therefore, the images have already started down a road, independent of what I might say, independent even of what Christinat himself wants to convey. These photographs are subject to the same reality as all published text: once they are given over to others they no longer belong to the author, but to those who will take them for better or for worse. As for what concerns the worst, I would nevertheless like to spare Christinat and his viewers from this misfortune: the misfortune of completely skipping over to what – or to whom – these images refer. This might result in confusion or questioning before "presences" that, overly confirmed by the past, might today appear to be absent. The best is clearly what the theologian believes: for me, these photographs speak of life and death, about our personal relationship to the beginning and end of existence, about God or the gods within ourselves. Some images even seem to ask for some hope or forgiveness. But I won't say more on this subject – not before readers, whether they are charmed or irritated, won over or disappointed, return from visiting this book with their questions, comments, and interrogations. Theology, in a case like this one, only comes later on and then engages in dialogue – or debate – concerning what has been seen, on conclusions made, on the questioning to which the images were subjected. Such a dialogue, such a debate, cannot be elaborated beforehand – otherwise it is no longer a dialogue or a debate. These exchanges should be discussed in person. For now, I will keep quiet and look. I am as free as a viewer, free to stay at length before carefully composed and considered images, free to pass over others, or even to close the book until the day when I can examine it, look at it, travel with it in complete receptivity.

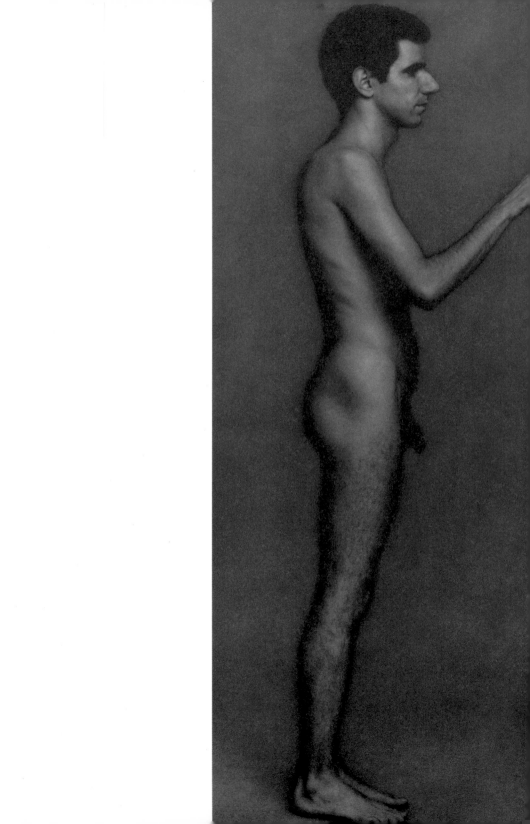

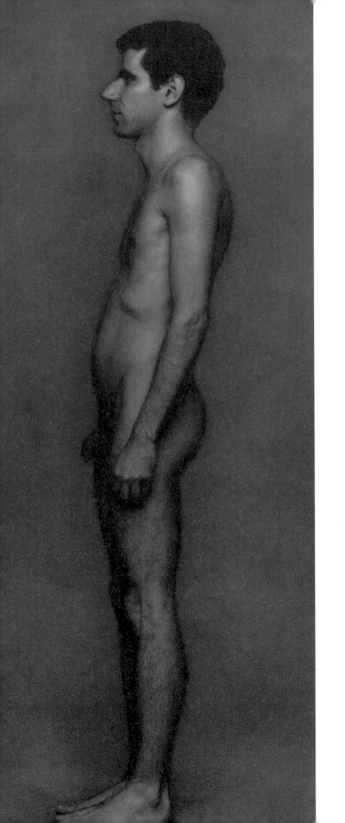

Dieu troublé par sa ressemblance (God Disturbed by His Own Image), 1995

The Temptation of Christianity Christophe Blaser

Christianity's profound and lasting appeal varies with different sensibilities and times. Ours seem to be tempted by Christianity's erotic potential. Is it not one of the only domains in which the clash between what is forbidden and what is transgression still produces some kind of effect? Is it not one of the only domains in which sexuality does not become completely commonplace? Sexual repression in the Church over the centuries has moreover guarded the mystery of an "Eros hidden" deep within Christianity, a mystery that has great evocative power. Few artists, however, have been subtle in revealing this erotic dimension. Perhaps only certain Surrealists have been up to the task (for example, Buñuel's *Viridiana* in which relics and fetish- ism, incest and sacred bonds of marriage, monachism and somnambulism, death and innocence come to- gether intricately). It can't be denied that most of the time attempts have given way to kitsch, and provoca- tion to rehashing. Understandably, Christians can only be saddened by the trend. Christianity seems to relate as much to sensibility and taste, as it does to faith. This is not a new idea. The Romantics were al- ready drawing on it, claiming to judge Christianity on the works it had inspired, and not on its truth. Defending this esthetic position came as a particularly welcome position at a time when the ardor of Atheism and Positivism was about to be unleashed. But, it also entailed certain risks. It suggested that Christianity was subject matter only for artists who, throughout time, had been called upon to celebrate it. One wonders if artists, unknowingly, did not alienate Christianity, de- tach it from itself and thus transform it from the inside. Was the niche that they gradually carved out for them- selves self-serving, at the cost of religious fervor? All these questions were to be answered in the affirmative. The Romantics laid down the foundations for a reli- gious revival in western art and literature. Later, this phenomenon became widespread. In the twentieth century, there was a return to figuration and the body, even a return to order after the "aberrations" of the avant-garde. We have to keep these prece- dents in mind when considering Olivier Christinat's

work. For him, the return to religion does not stem from a faith he wants to prove and show with mixed feelings; it is not part of the Christian renewal that has been underway for quite some time. It does not even grow out of a vague need for spirituality. Art, especially in the twentieth century, has shown that it can meet many of the needs in this domain, that it has absorbed the religion from which it came. Christinat's perspective belongs to this horizon. It was through art that he came to question Christianity. Even though we cannot exclude the possibility that he may use art to eventually address God, the specificity of this detour must be understood. If we consider the detour only as the step towards conversion, we do indeed run the risk of missing the main point. It's better to trace some of the many steps along the way in order to reveal its complexity.

On many occasions Christinat has touched upon Christianity, without overtly acknowledging or pursuing it. His considerations of the nude, when he chooses to tackle the subject, is part of his return to the body, a characteristic subject of art during the 1990s. He therefore engages in disillusioned narcissism. Following in the footsteps of John Coplans, he considers his body without complaisance, cultivating certain forms of pathos. However, he departs from Coplans in that he does not focus on physical decay (besides, he is too young to have that need). His photographs suggest fragility, even suffering, an impression fostered by nudity and frailty, and also obscurity. The series of male *Torsos* and *Nudes* exemplify this period. They establish a link with Christian tradition, in which, depending on the time, the problem of the body could not be dealt with, except to deplore, restrain, or sublimate it. In the past, Christinat had already taken pictures that undeniably fell in line with this tradition, for example *Indolence I* and *II*. His use of light, coming from above and signifying transcendence, was strictly Christian. The photographer proved to be a champion of a chiaroscuro rhetoric that was rich and dramatic in effect. More specifically, his art echoed religious art after 1600, especially Catholic art, and its violent contrasts. A first exchange had begun. *The Beginning* is

certainly a turning point in terms of the theatricality of Christinat's preceding series of works. Although there is still pathos in the images, it no longer results from chiaroscuro or the expressiveness of the naked body, but rather from where the body is, imprisoned, isolated, as if enclosed in a box. As is indicated by the title of the series, some of the figures seem imprinted in clay, as if the body had been placed in a mold, leaving its shape. An imprint is a kind of stamp, and something similar may be said about photography. We can understand, therefore, why it appeals to Christinat. And it is not his only incursion into this domain. *Profil*, for example, refers to another contact process: wax casting and death masks. *The Beginning* is clearly influenced by the Bible, in that it makes an obvious allusion to the clay used by God to create man. A freer interpretation is likely to confirm this source of inspiration even more: one might perceive a relationship between Christinat's primitive alphabet, body imprints in clay, and the early writings of Near-East Antiquity, the origin of monotheism, which used similar techniques. Of course, these meanings are implicit. And often, as in this case, they are only specified after the fact, once the piece has been completed and once discussion is underway.

The explanation is offered in *The Meal*, a kind of postmodern remake of *The Last Supper*. Christinat has depicted himself thirteen times as a contemporary man, sometimes in casual wear with a turtleneck, sometimes as a young professional in a suit and tie. He is seated simply amid minimal décor. We are far from Cindy Sherman's pseudo-historical color reenactments. The central Christ figure does not have a face. His guests are indifferent to each other. Most of them do not seem to show any emotion. A certain kind of detachment that verges on coldness emanates from the group. The fact that this detachment is expressed by Christinat's first confrontation with a Christian subject is not a casual one. We suddenly have a glimpse of the limitations that he sees in his return to religion. The more his aim becomes clearer and his challenges specific, the more there is the need, so to speak, to distance himself as a counterpart. While the idea of

creating dark figures and backgrounds has roots in *The Beginning*, the detachment that Christinat perceives as an esthetic outlet for his agnostic hesitations doesn't really come to the surface until *The Meal*. These two elements henceforth form the substance of the photographer's esthetic. Nevertheless, the detachment is developed, amplified to the point of irony. Yet the notion of using his own face to represent God is not rejected (*God at a Loss to Know How to Use His Power*, or *God Tempted by Chance*). Furthermore, the eroticism of the nudes is neutralized and the temptation to be provocative with religion – which is so strong today, and so conventional (Andres Serrano's *Piss Christ*, a crucifix submerged in urine, might be the epitome) – is resis-

ted. Reformation and Counter-Reformation came together to stifle a sexuality that Christianity has not always sought to avoid and, on certain occasions, has perhaps even tried to redeem. Thus, serious studies have emerged that purport that religious art from the Renaissance did not resist eroticism per se. At that time, Crucifixions or Sorrowful Men with oddly swollen perizonia, and depictions of the baby Jesus with blatantly exhibited genitalia abounded. Was religion trying to humanize God as was done a few centuries before by the movement to honor the Virgin, or was it proving to be under the positive influence of the ancient pagan cultures championed by humanists? The question is left open, and it is up to historians and

theologians, not to critics, to show if the ithyphallic deities of Antiquity were models for certain crudely virile depictions of Christ during the Renaissance. With regards to Christinat, one will note that, instead of proposing a complete break, he is reassembling the pieces of a dialogue that had hardly begun before it was interrupted. Although the eroticism of his nudes has been refined and purified, and although his sober, minimalist esthetic appears Protestant, he gives the impression of wanting to find Christianity as it was before the Schism, when one sought after a God that was more intimate, more familiar. If this were the case, there would therefore be an alternative to the various forms of fundamentalism (Catholic traditionalists, charismatic

Protestants, etc.) which all revolve around the notion of a strict God, and which, nowadays, are being revived.

A Protestant esthetic? The expression is sometimes used in regards to Christinat. He even uses it to describe his work. But, is it really justified in his case? And moreover, can we really speak of a Protestant esthetic? In light of the iconoclasm of the Reformation, the very idea of an esthetic seems compromised. Yet, upon careful consideration, it is easy to give it some weight. First, because Protestant style must have had to come to the surface; and also because its first impulse was naturally to distinguish itself from dominating Catholic style, with its main consequence being the crystallization of a "negative" esthetic. Catholic art being theatrical, illusionist and exuberant, sensualist and naturalist, Protestantism could only define itself by developing diametrically opposed canons. Art criticism of the last century, especially in Anglo-Saxon countries, was greatly responsible for introducing these canons, after having specified the content. It is probably thanks to Ruskin and his school that we now still believe that art should be edifying, simple and sincere, profound, serious and austere, clear, raw, and true, although its very nature is to be artificial, to imitate, to have pretenses. The Protestant viewpoint has asserted and perpetuated itself by seeing art as a pure, untainted ideal, as a moral discipline inspired by religion, while ignoring the autonomy gained by esthetics vis-à-vis ethics. Its influence continues to be strong and still determines our most "spontaneous" responses. The disgrace that Baroque art suffered and the immense popularity that Roman art continues to enjoy, are due to this Protestant perspective. The same explanation can be given for the favorable reception given to Islamic art in the West and for the lack of enthusiasm towards Hindu art. It is likely that Christinat – and everyone else – is in the grip of a significant Protestant esthetic. It is, however, more difficult to imagine that the artistic asceticism he practices can be assimilated as is into this esthetic. It is true that the rejection of kitsch and popular fantasy – Bettina Rheims' book *I.N.R.I* well illustrates this fascination with religious kitsch – is

similar to the Protestant desire to promote an approach that is disciplined, contemplative, and also individualistic, protected from the whims of the masses. Certainly, the reserved, cold tone is diametrically opposed to expression based on emotion, as Catholic propaganda considered it to be for a long time. But these characteristics, at least some of them, can also be found in contemporary art, that is to say a deep suspicion of the passionate, emotional demonstrations and popular phenomena so often expressed in modern art. And what is to be said about irony? And the return to the body, in all of its manifestations, the narcissism, the self-representation, the staging? One will discover that there is as much in common – if not more – between Christinat's approach and the art of the last third of the twentieth century, as there is between such an approach and the Protestant esthetic. Minimalism – in which the photographer has been completely immersed since 1995 – might also come to mind, as well as certain movements post 1960, and in particular minimal art. There is a disturbing parallel with minimal art, with photograms like *The Last Night Before the First Day* and certain images like *Eden*, or even *The Chalice*, once again showing an interest in transposing the experience of sculpture into photography. Clearly, it is not easy to make sense of it all; unless, of course, one supposes that contemporary art could be the result of a Protestant esthetic. This is a reasonable hypothesis, considering North America's influence in painting and sculpture since 1945. The geopolitics of Christianity would be reconsidered from the perspective of post-war art history, from the emergence of new trends. It would give rise to a Protestant hegemony relayed – if not spearheaded – by contemporary art. Consequently, we would have a vast sphere of influence governed by minimal art and conceptual art, outposts maintained by kinetic art and support/surfaces, and buffer zones filled with hyper-realism and *arte povera*. Before our eyes it would outline new developments that would surprise us with their importance since we are so accustomed to the spectacle of a Catholicism that is traditionally more protean than Protestantism.

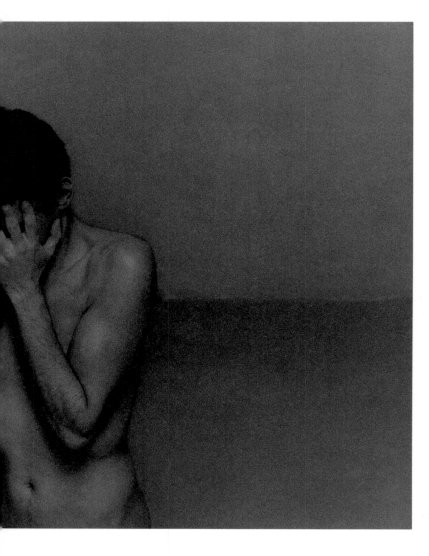
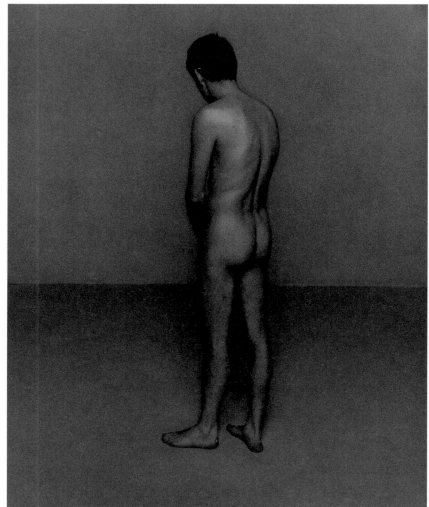

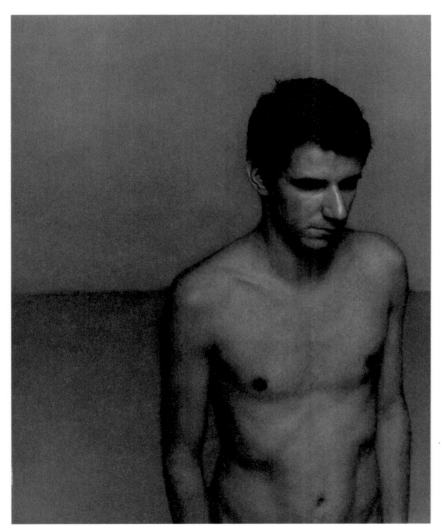
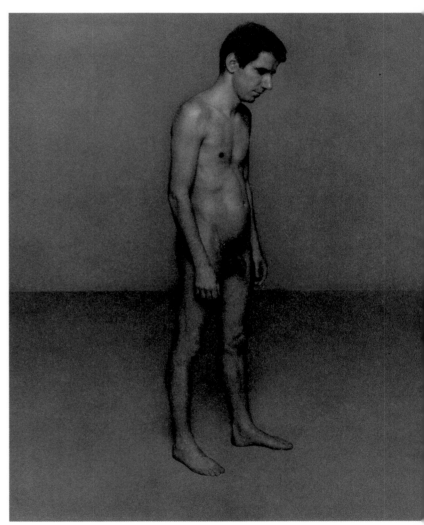

Golgotha (Golgotha), 1997

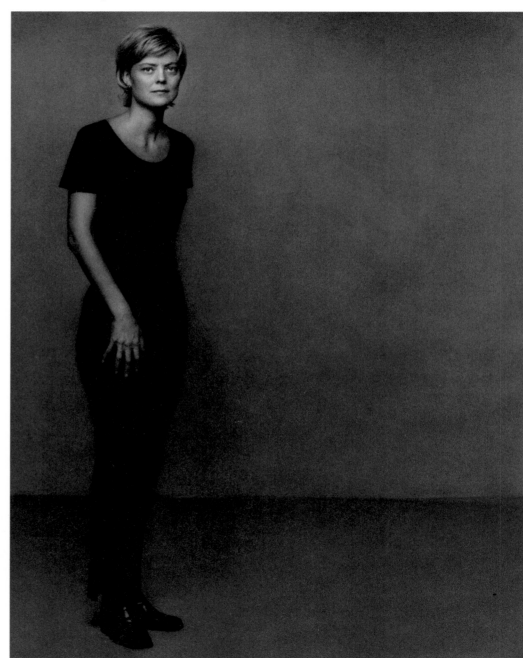

La femme de Lot (Lot's Wife), 1998

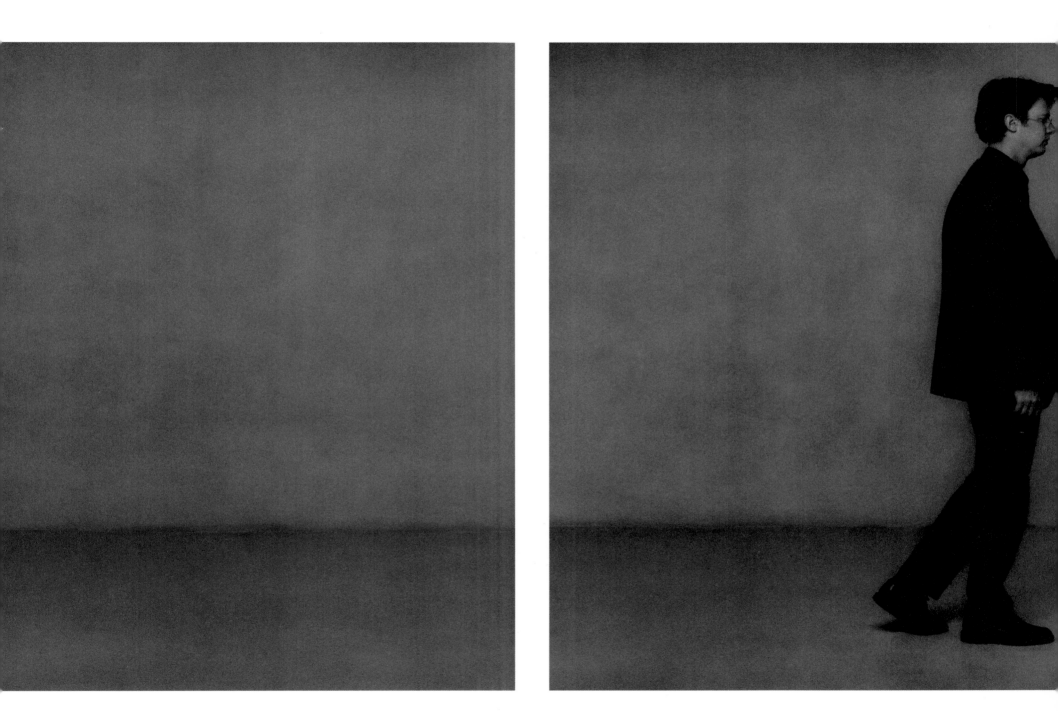

L'annonciation (The Annunciation), 1995

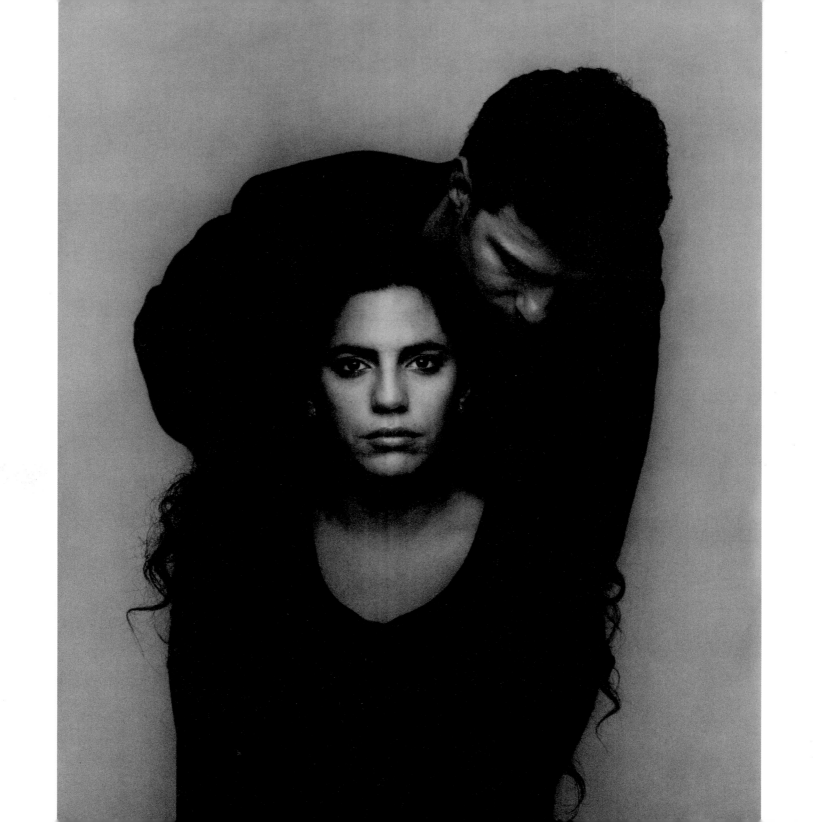

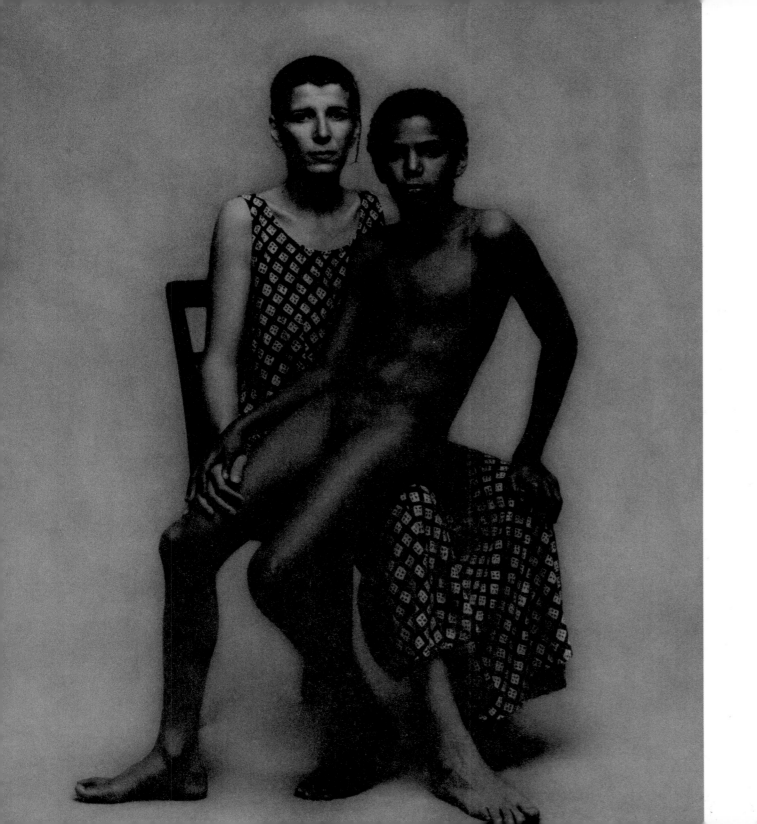

Nativité
(Nativity), 1995

En attendant l'Esprit-Saint
(Waiting for Holy Ghost), 1995

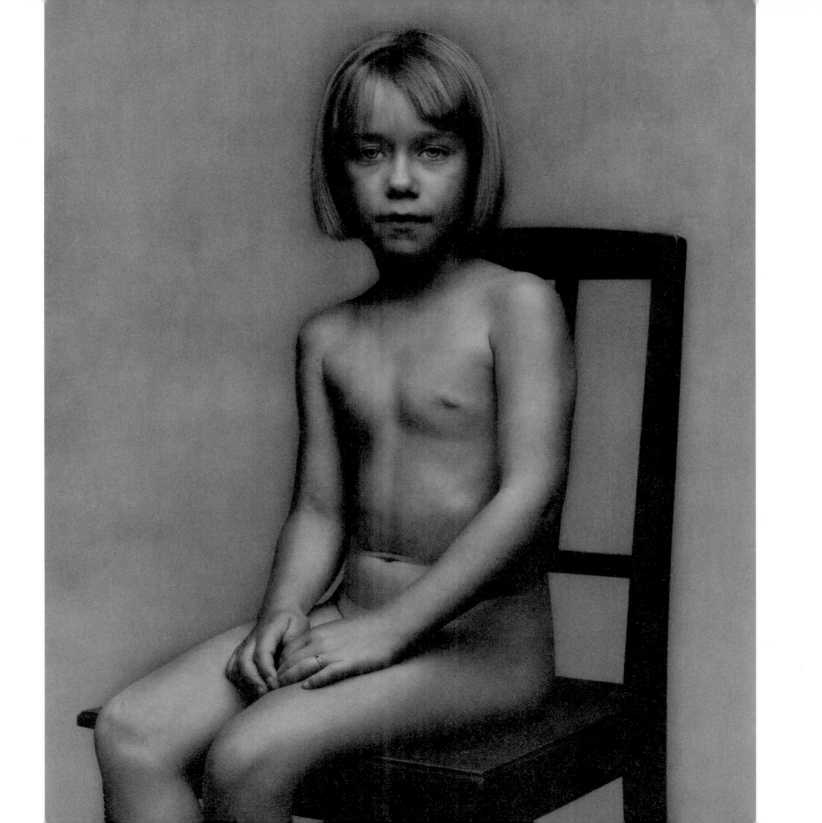

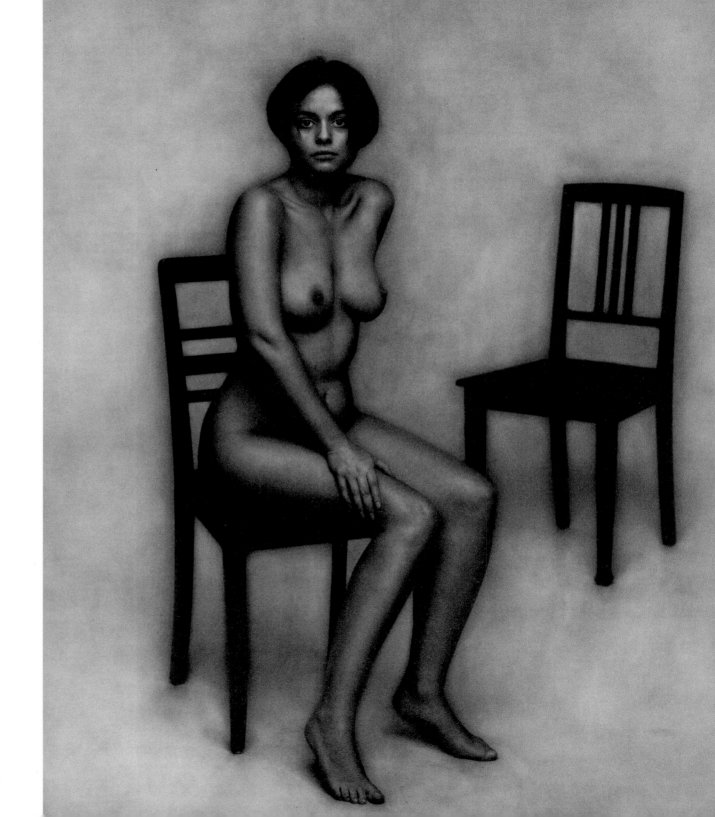

La promenade d'Adam (Adam's Walk), 1996

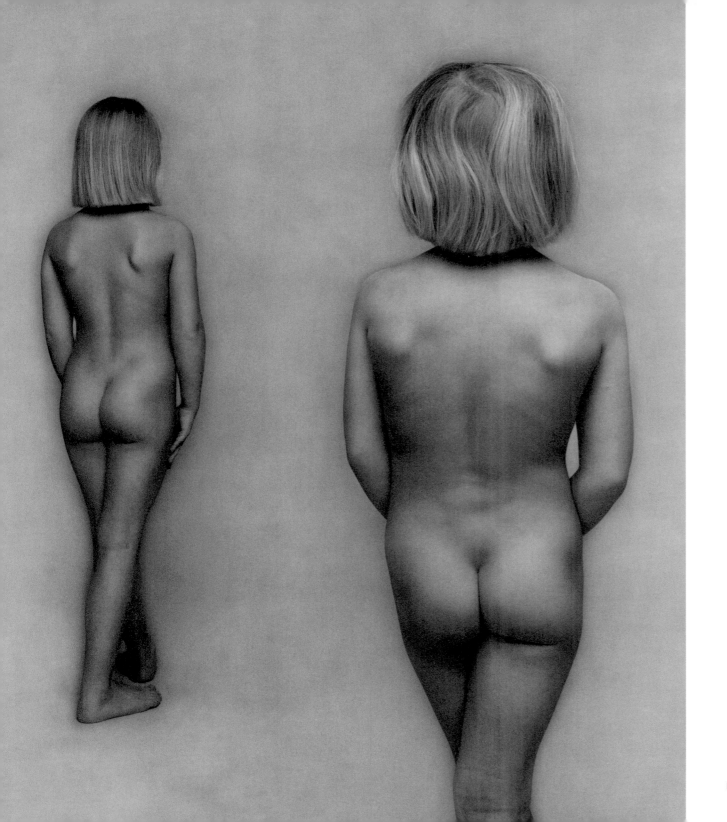

Exode (Exodus), 1996

Ce qui peut être nommé II (That Which Can Be Defined II), 1996

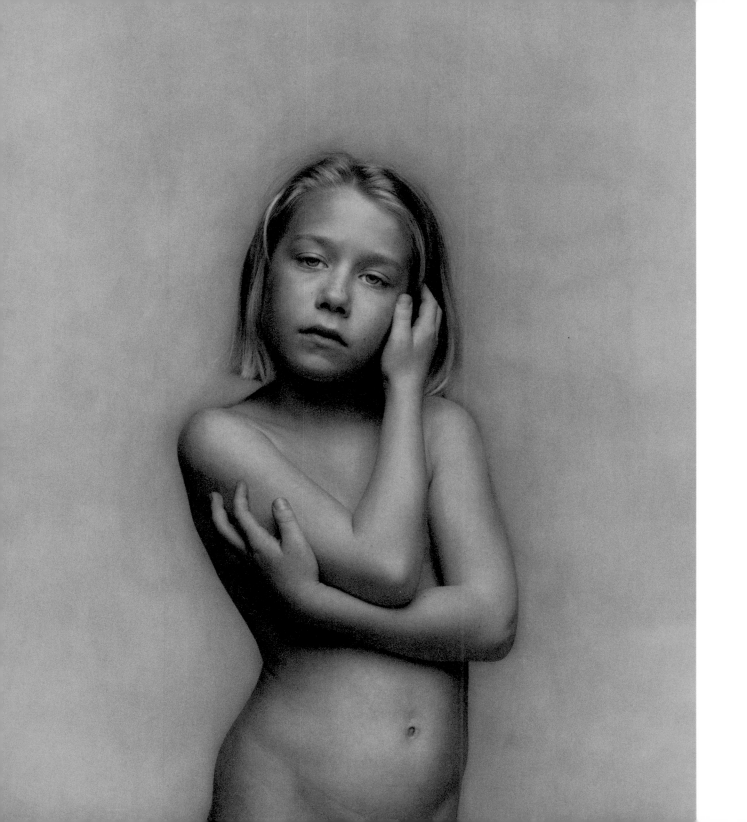

Ève encore nue (Eve Still Nude), 1996

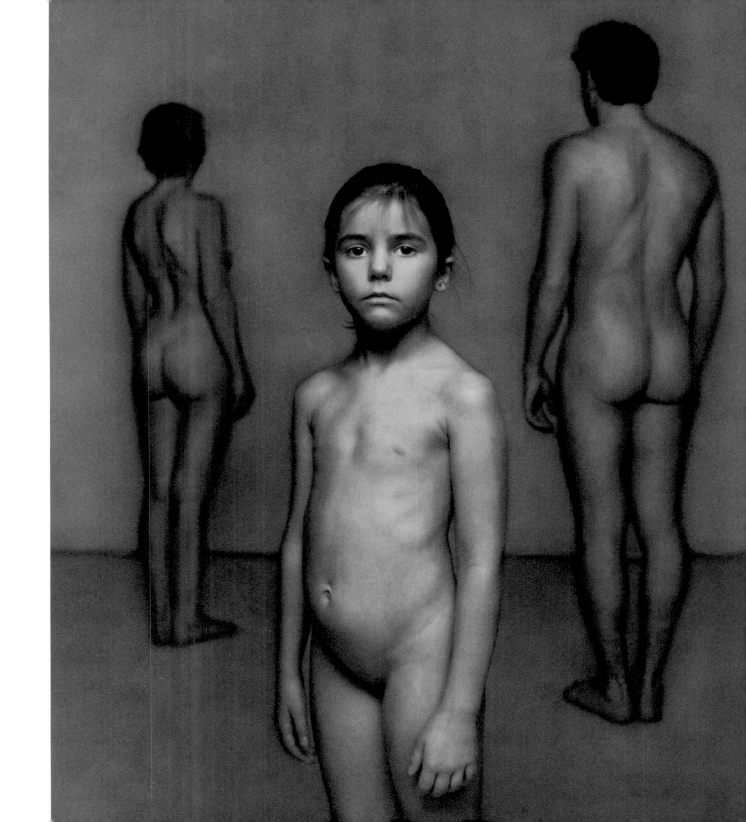

Paradis perdu (Lost Paradise), 1998

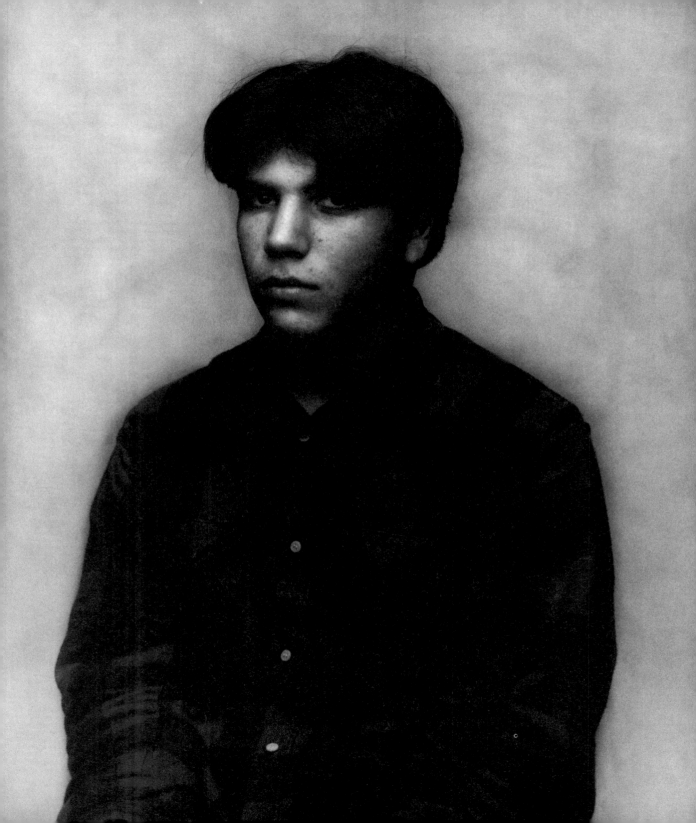

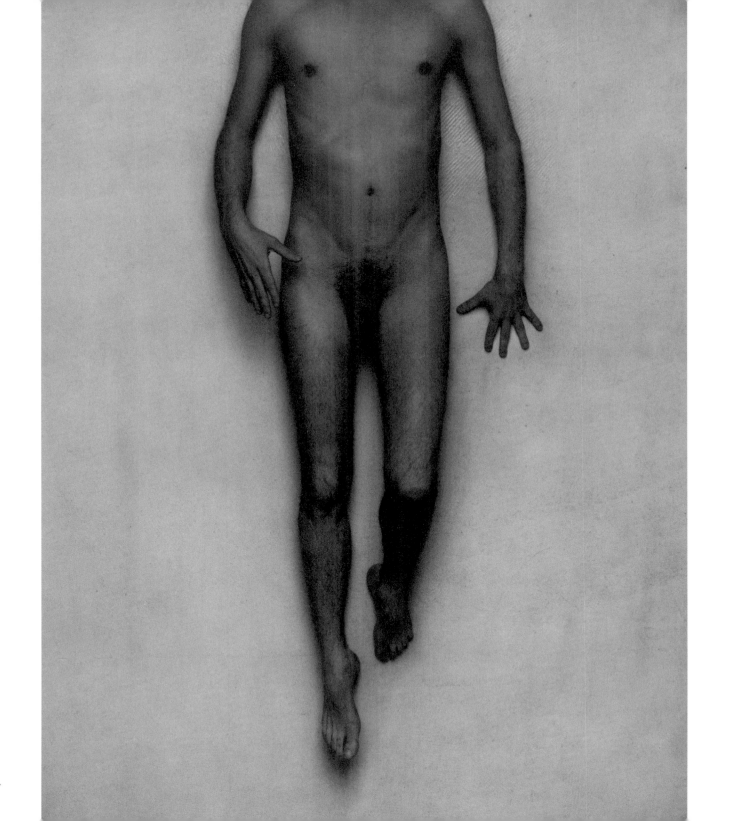

Théophanie (Theophany), 1997

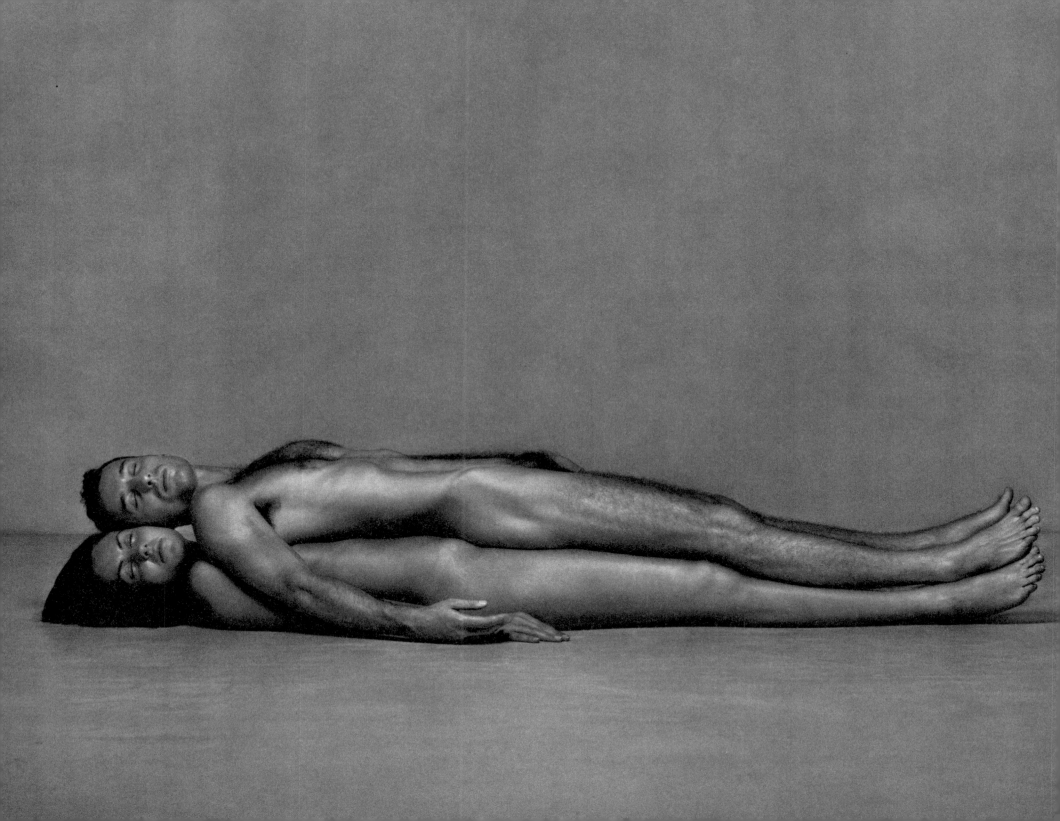

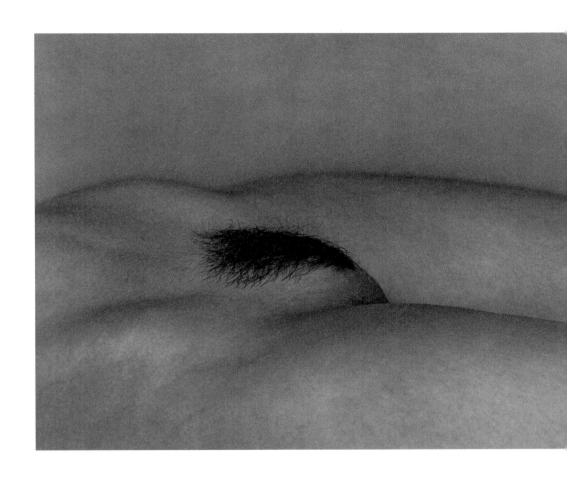

Hanania et Shapira (Hanania and Shapira), 1998 Ce qui peut être nommé III (That Which Can Be Defined III), 1996

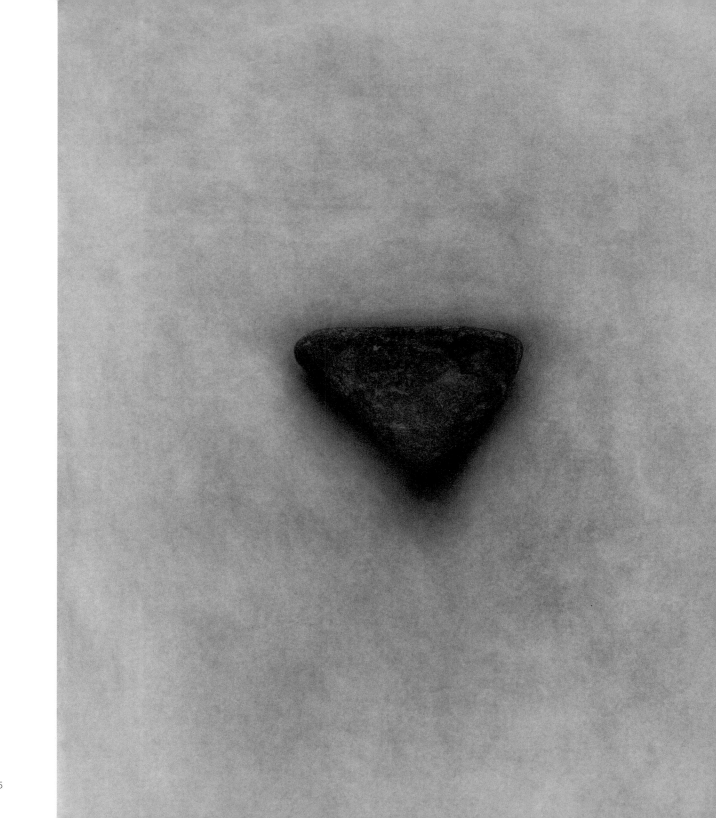

La première pierre (The Keystone), 1995

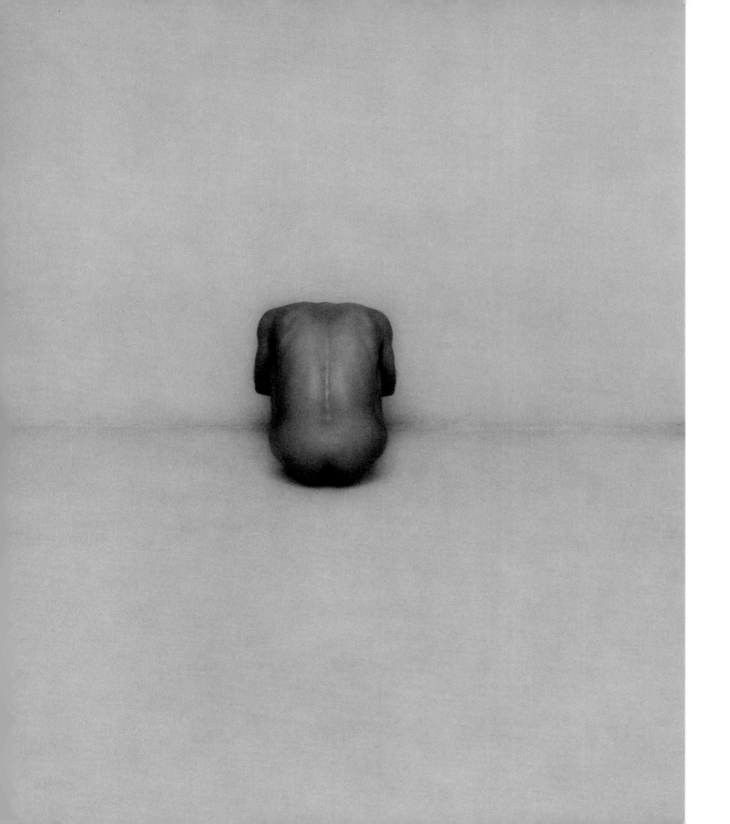

Le calice (The Chalice), 1996

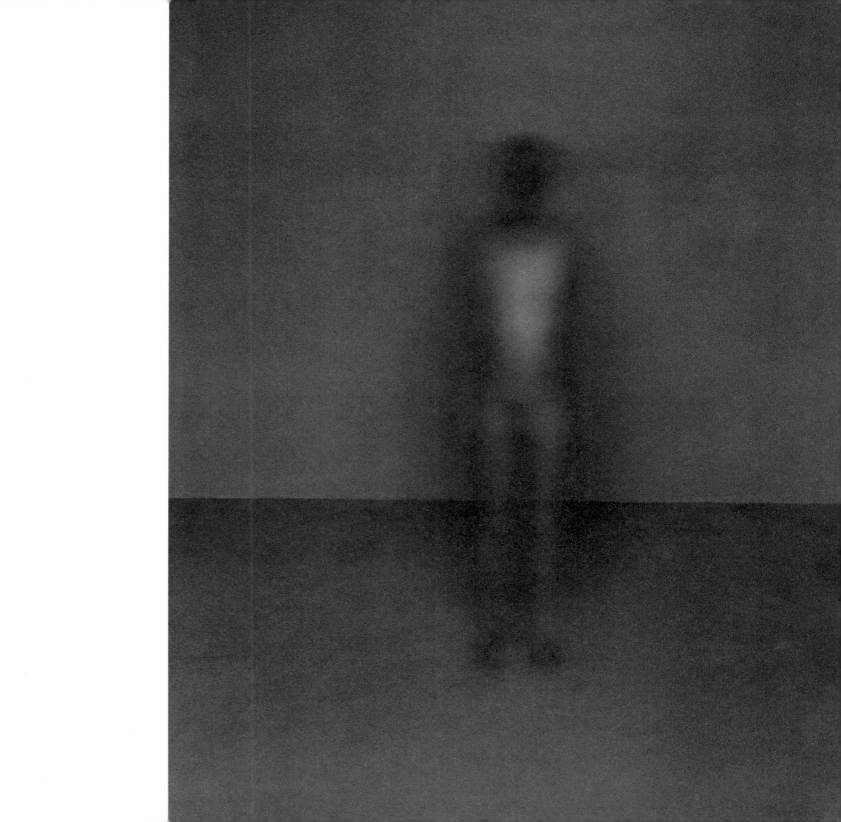

La nuée (Mist), 1998

L'interdiction de l'image (Tabou), 1997

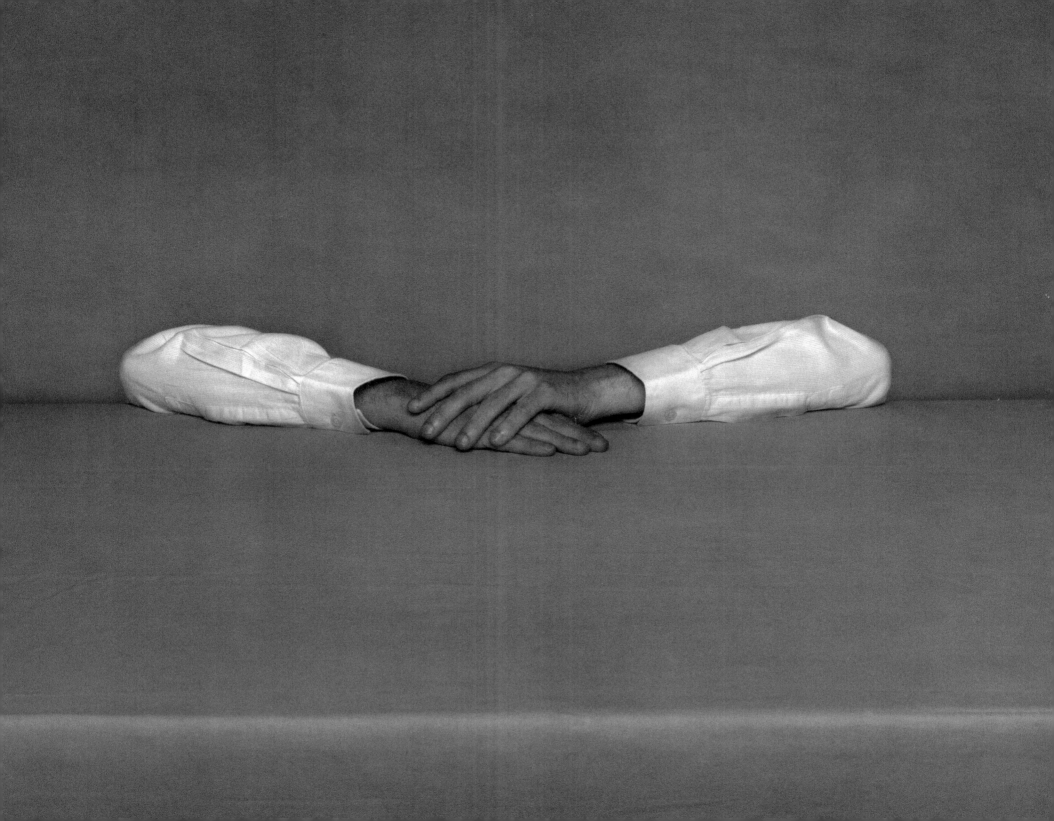

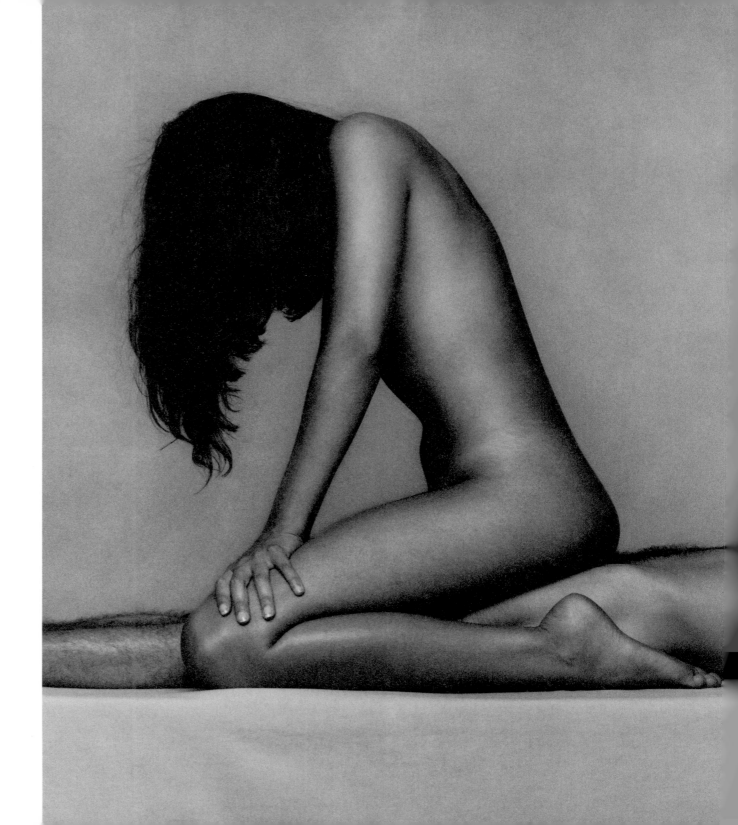

Les filles de Lot (Lot's Daughters), 1998

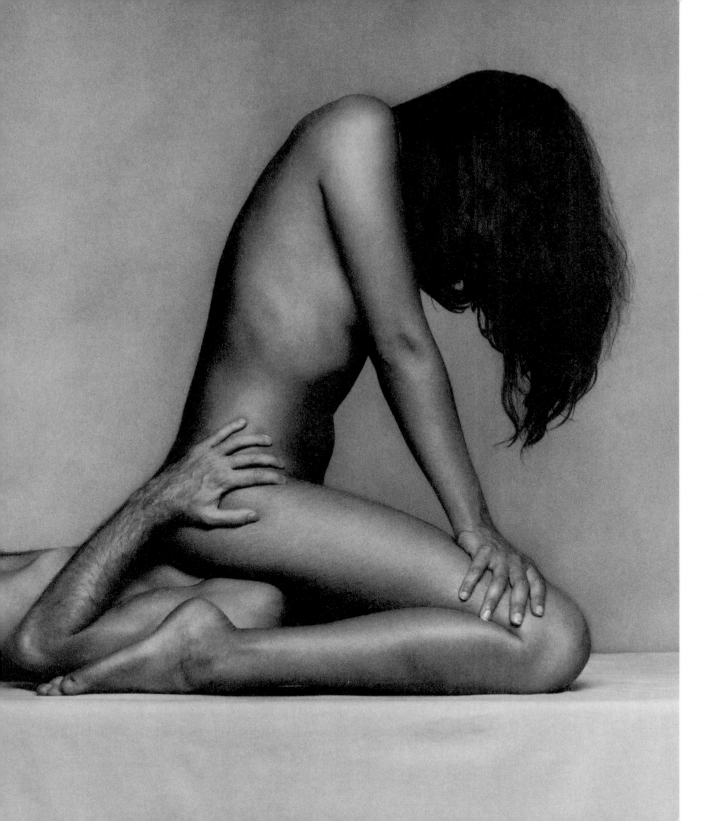

page suivante La fille de Jephté (Jephta's Daughter), 1998

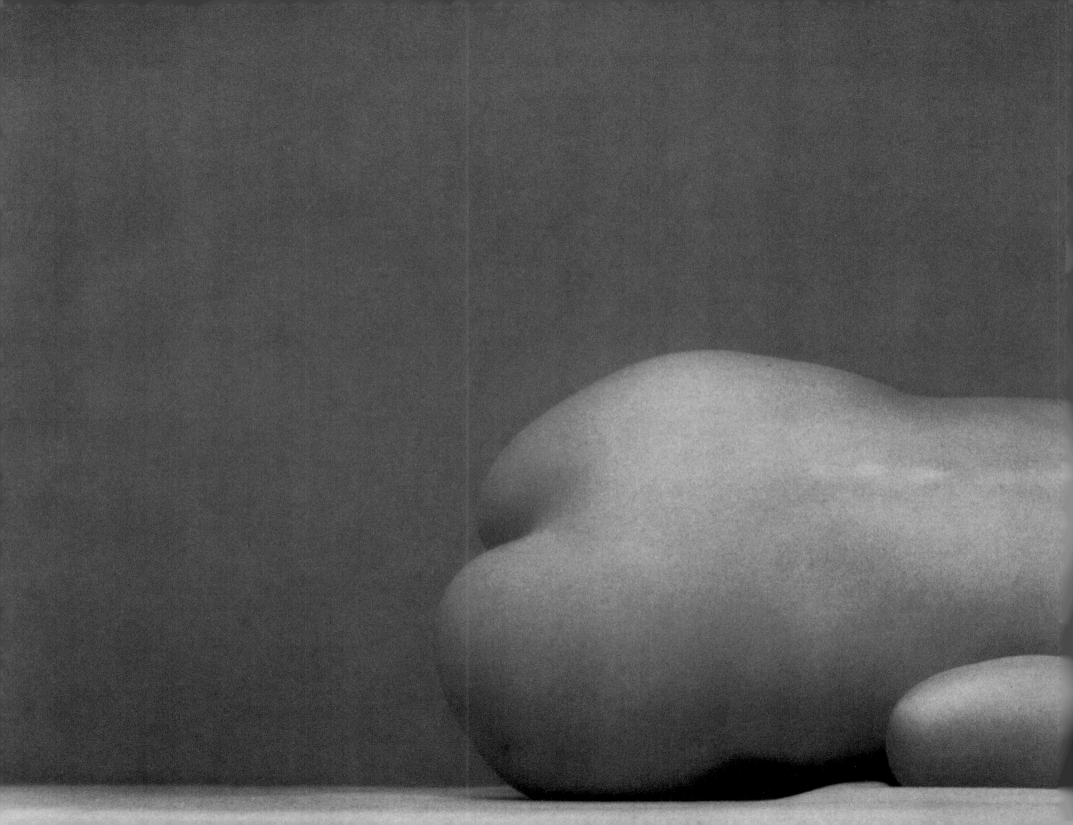

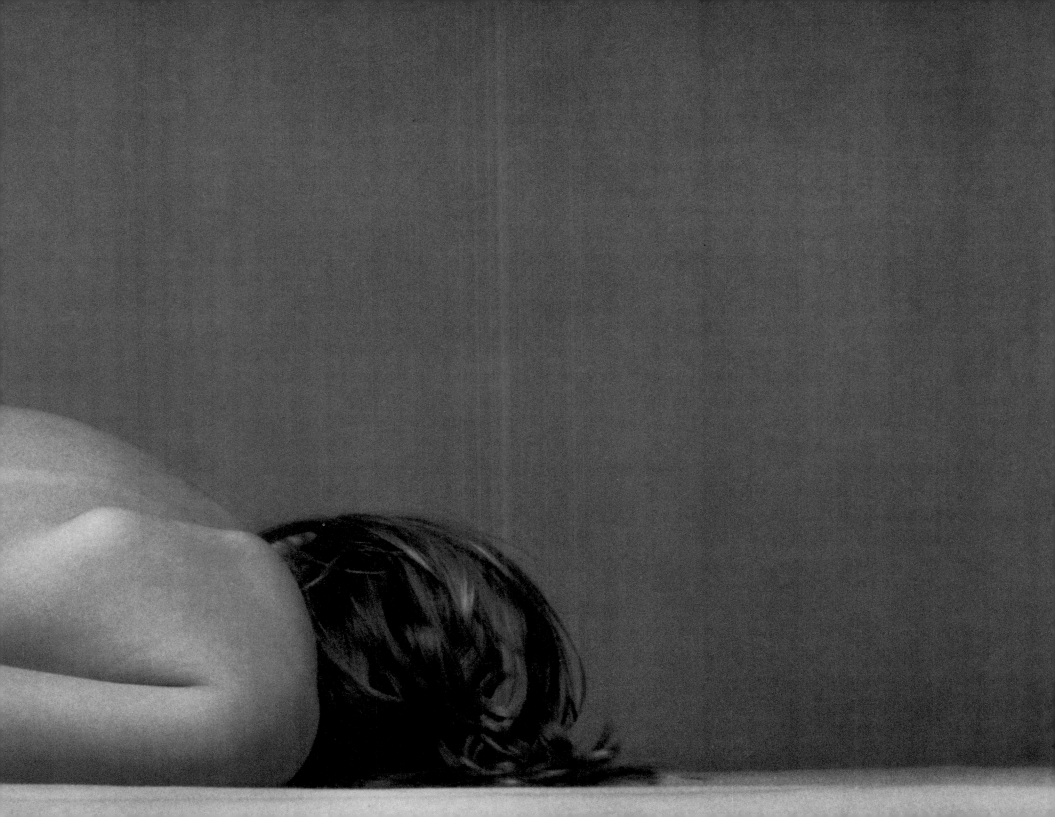

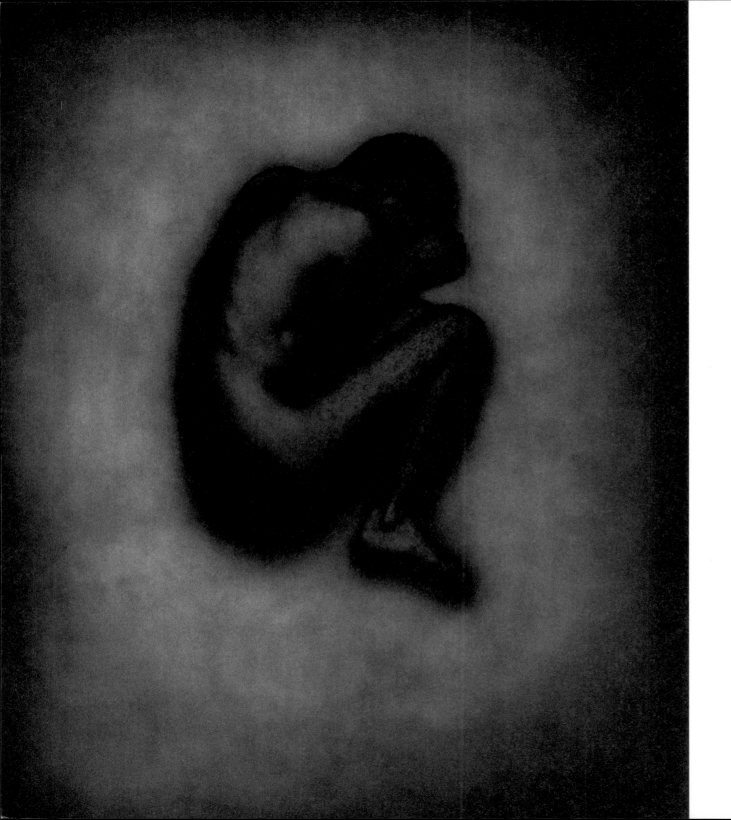

L'homme d'argile (The Beginning), 1994

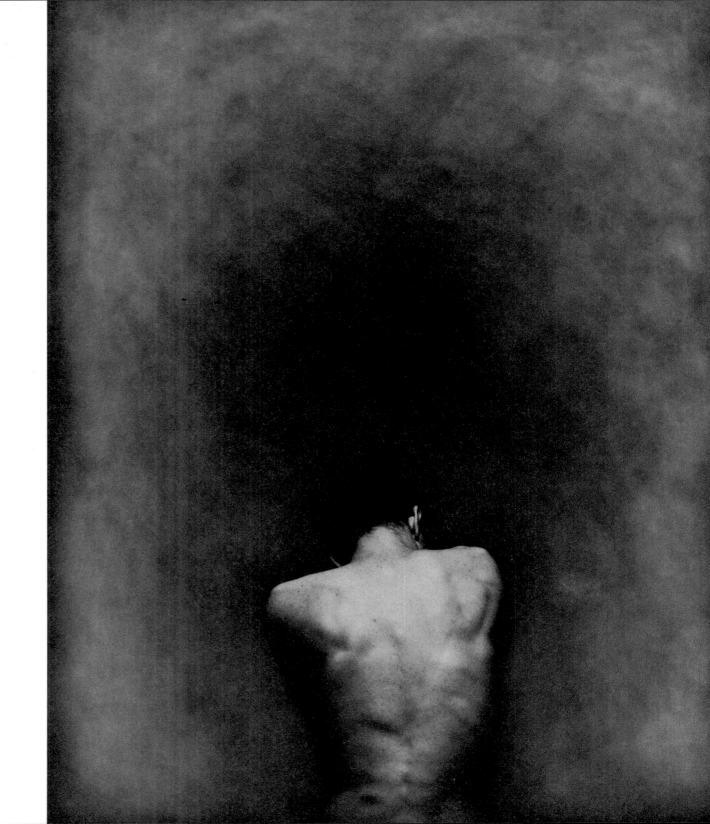

Le huitième jour de la création... le doute
(The Eighth Day of Creation... Perhaps), 1994

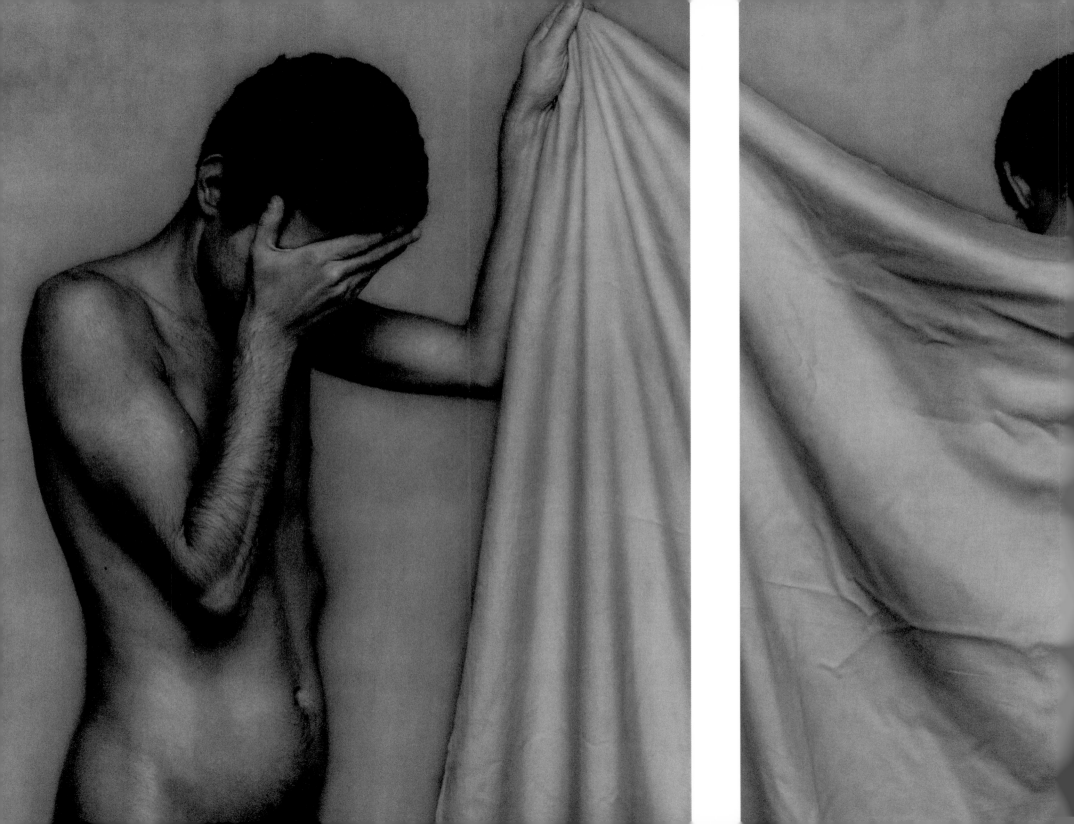

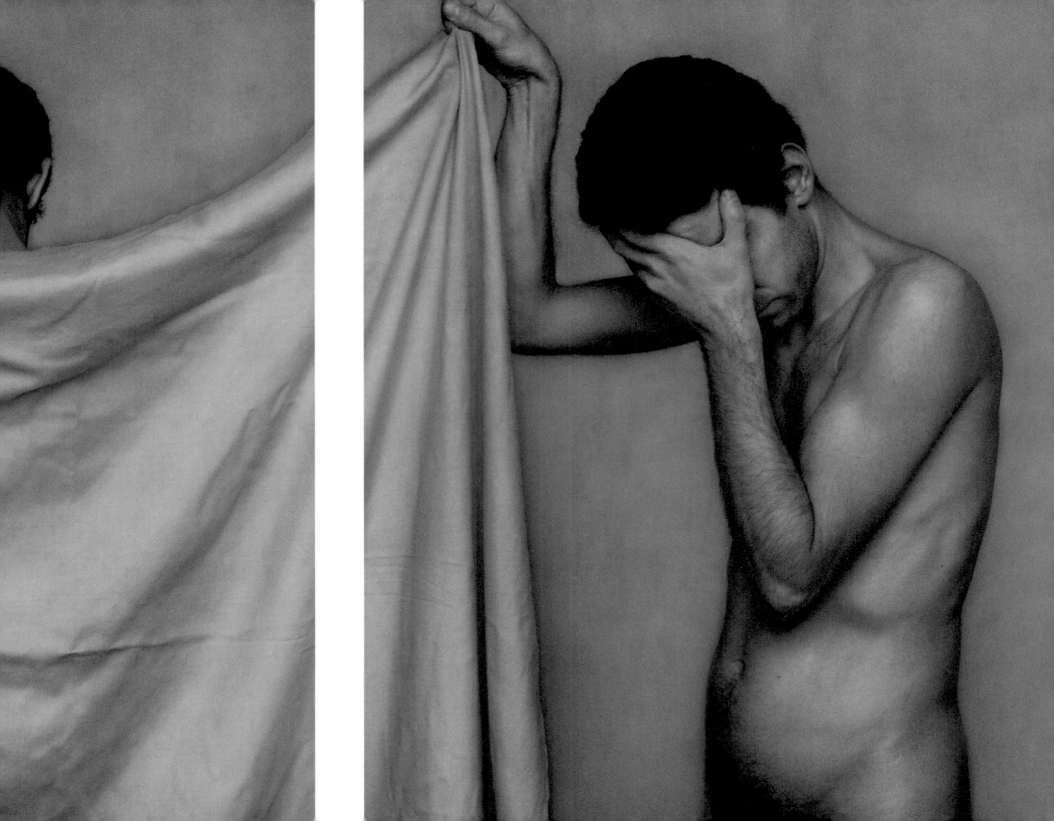

pages précédentes Le complexe de Sem et Japhet (The Sem and Japhet Complex), 1996

L'échelle de Jacob (Jacob's Ladder), 1996

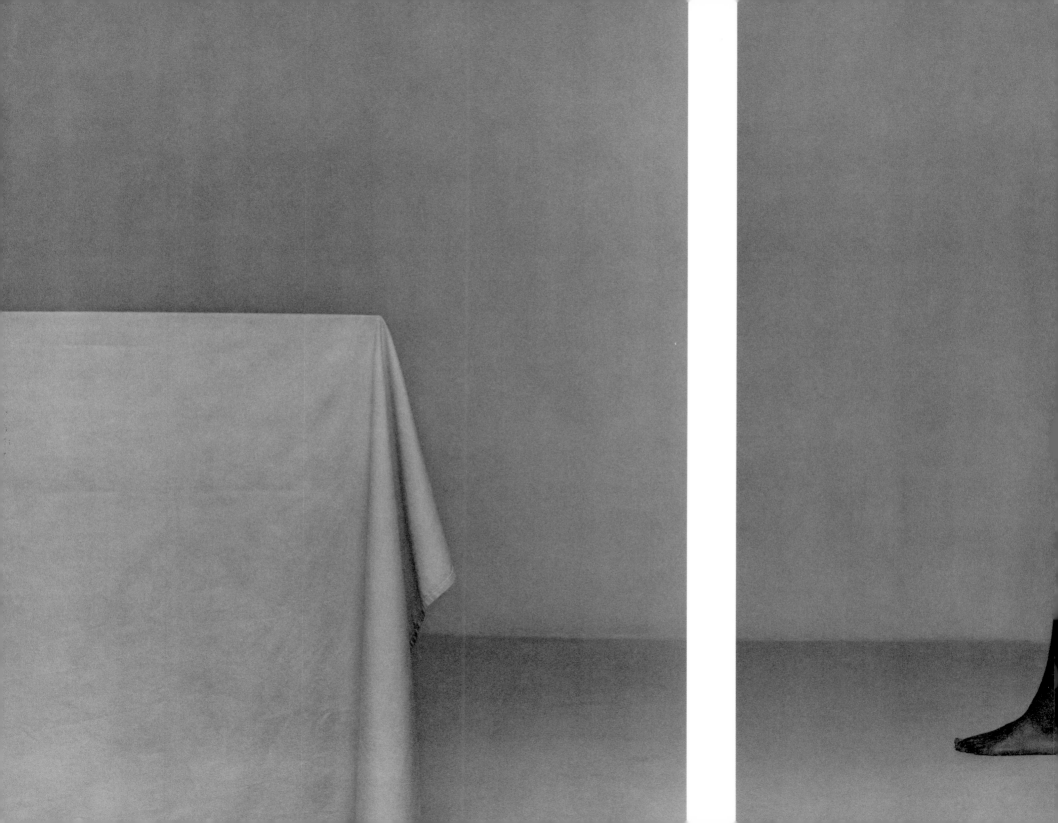

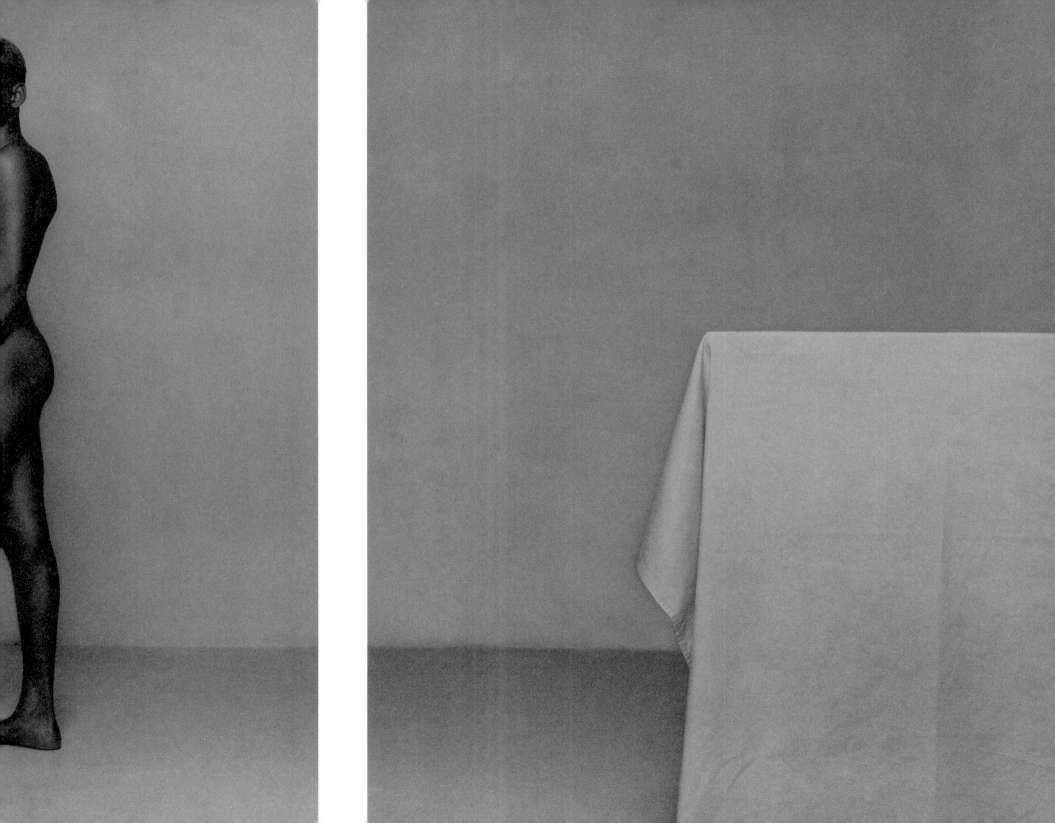

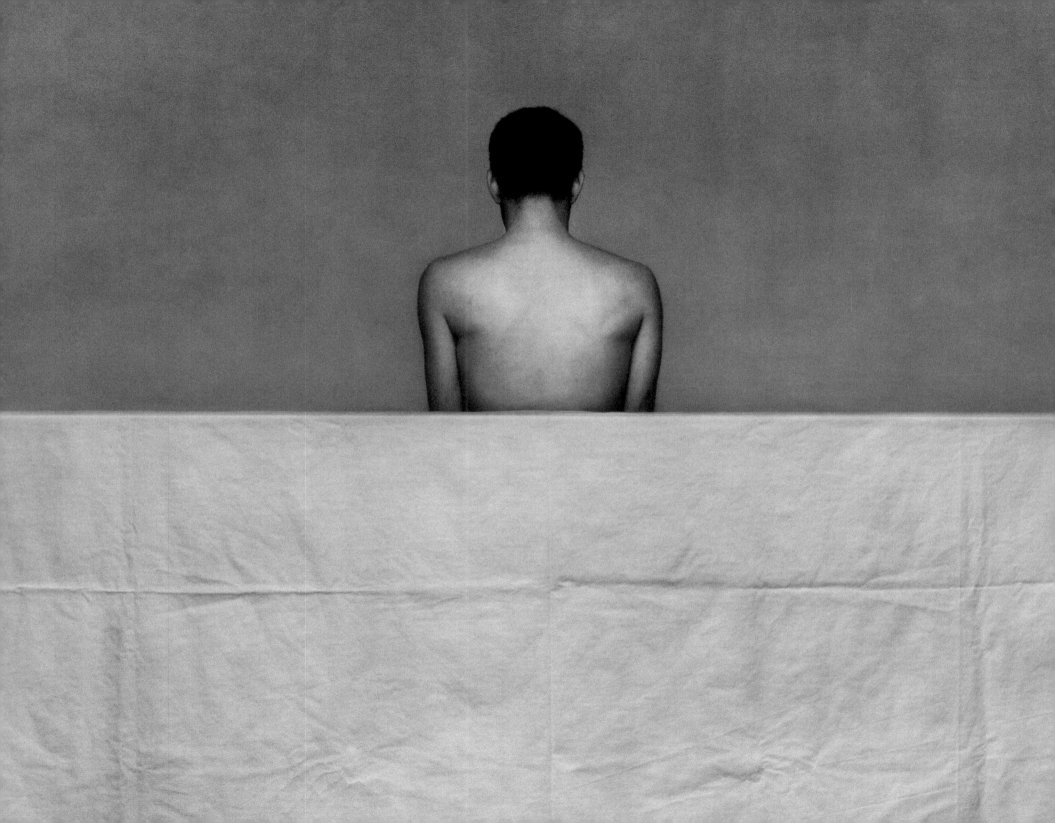

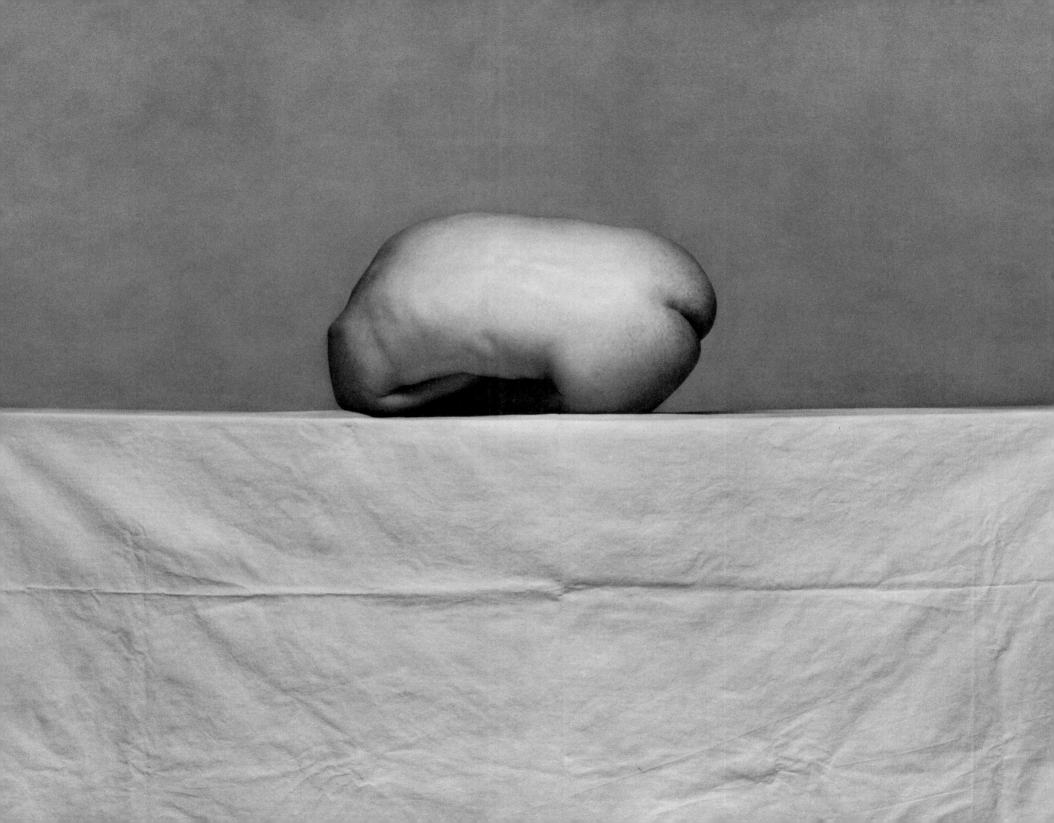

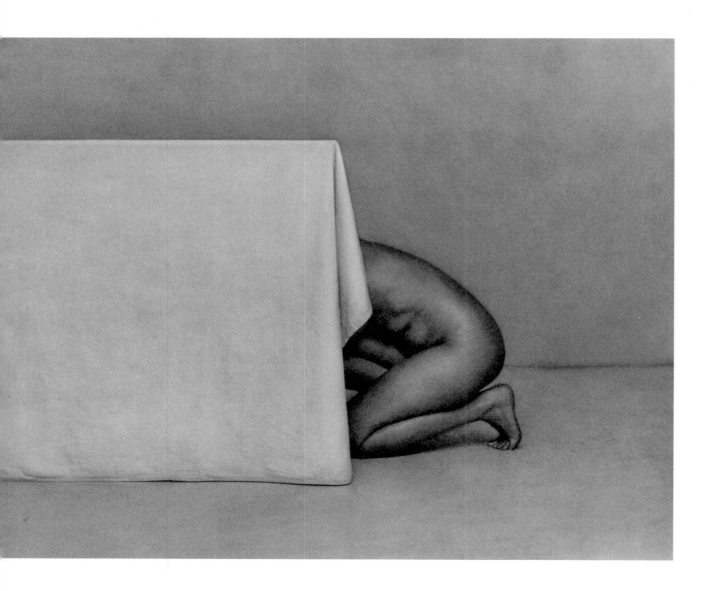

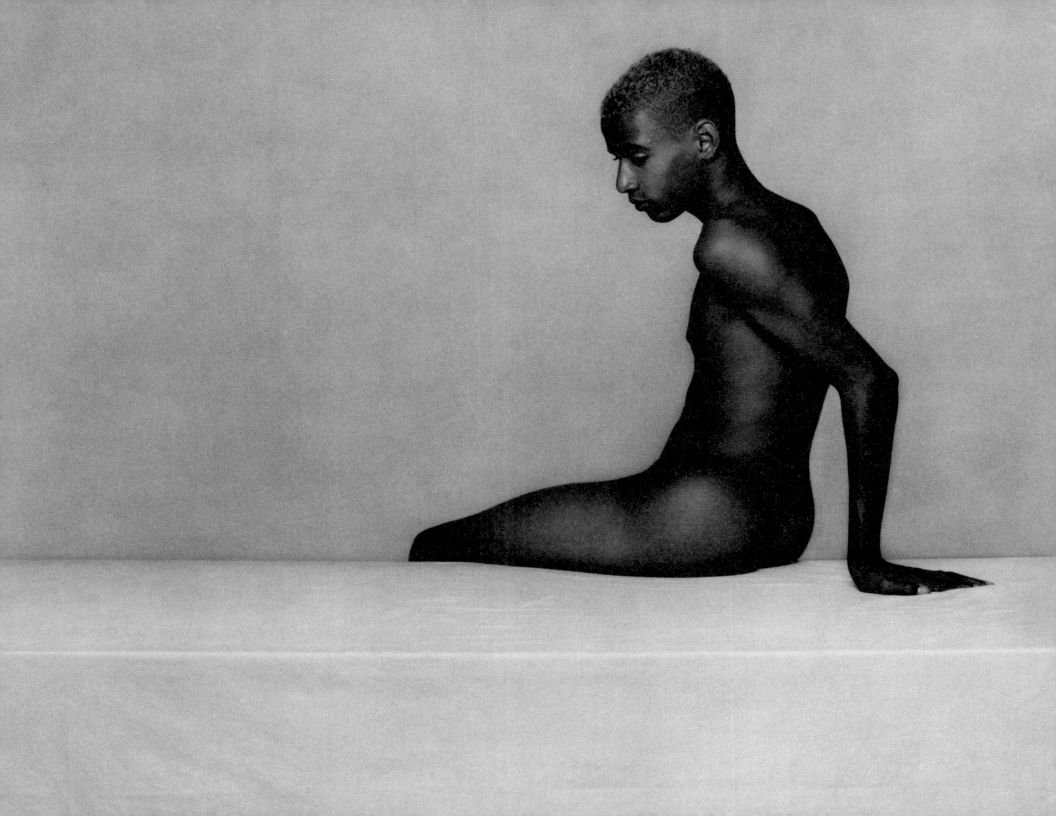

pages suivantes Les larmes de Rebecca (Rebecca's Tears), 1997

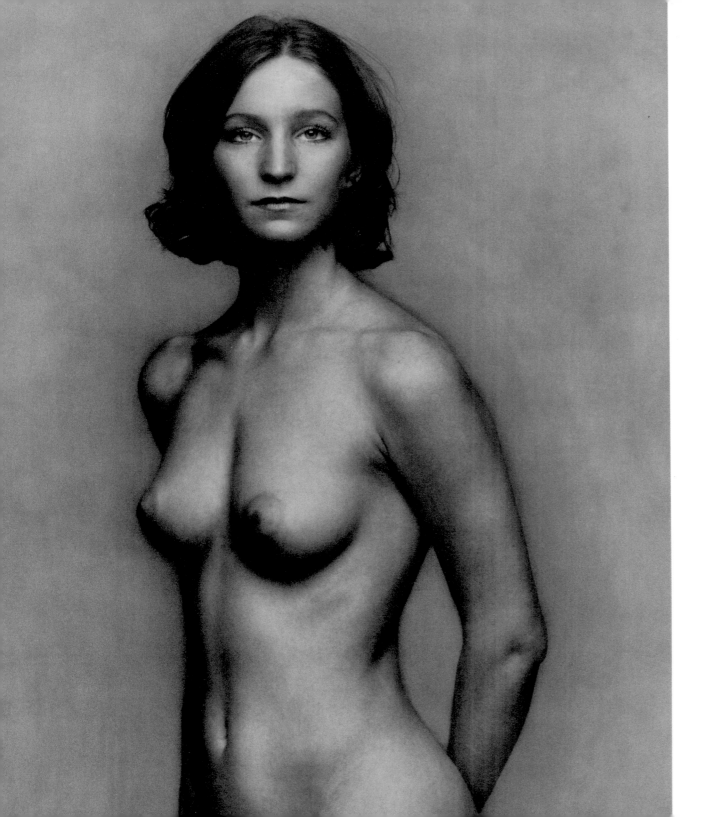

Devant le silence du ciel (Before Heaven's Silence), 1996

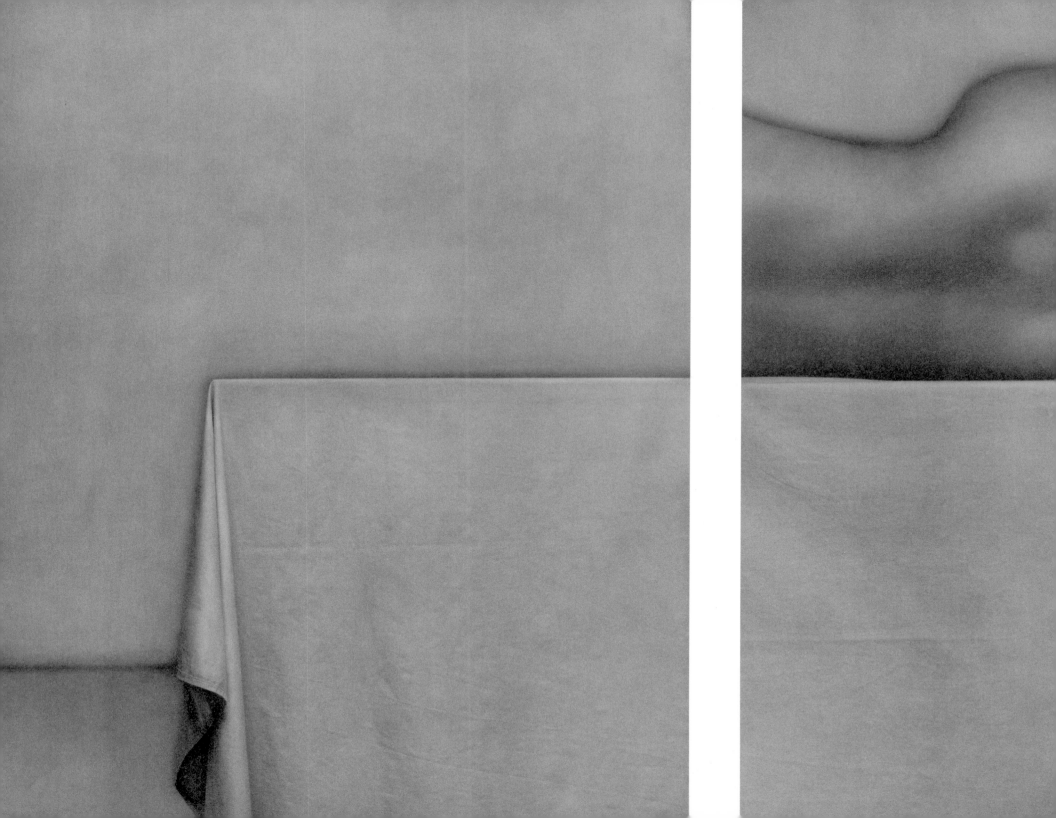

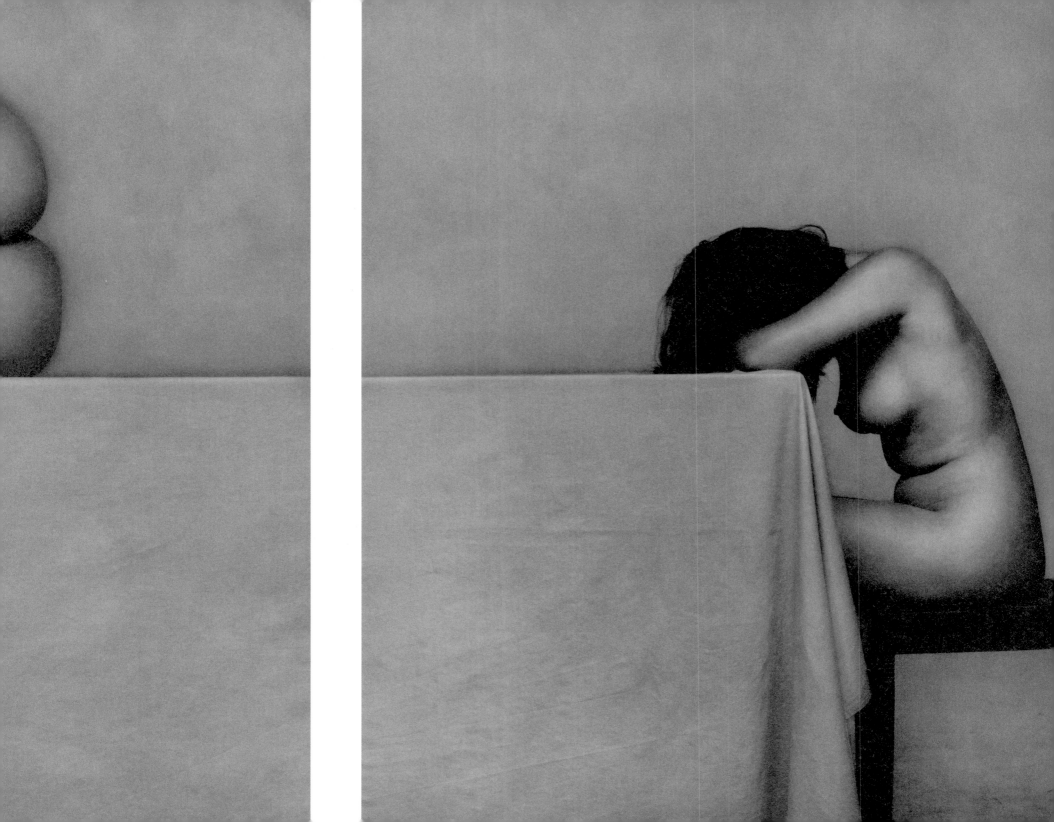

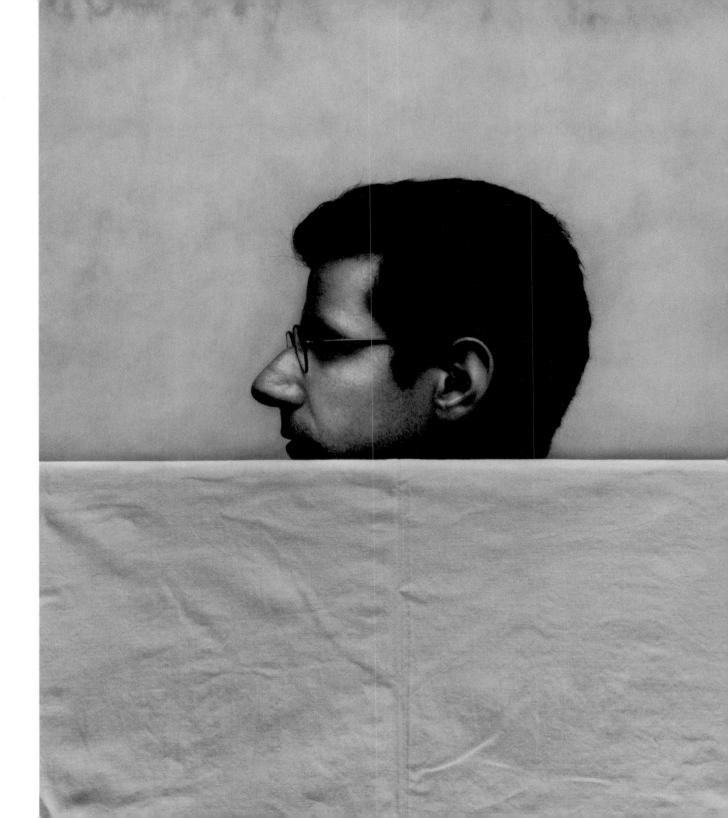

Le reniement (The Renouncement), 1996

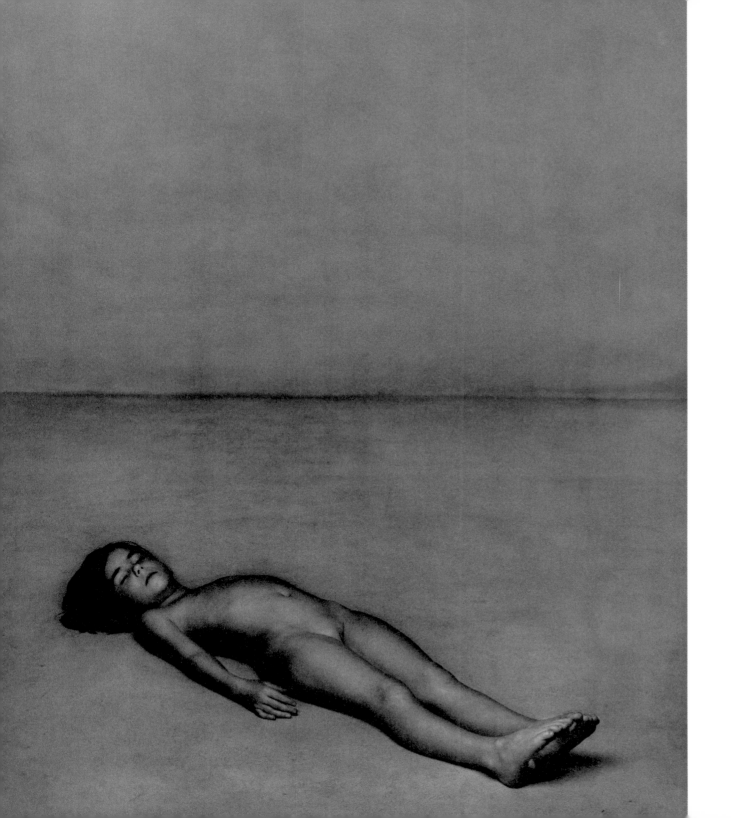

Déposition (Deposition), 1998

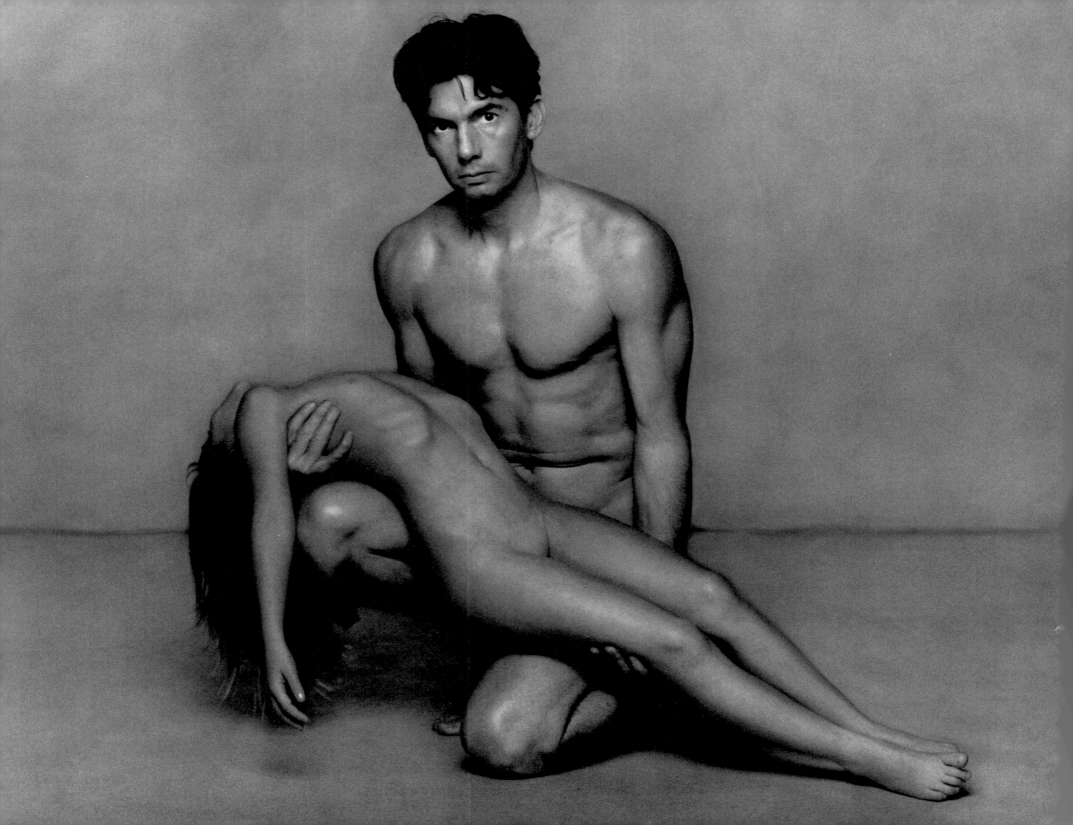

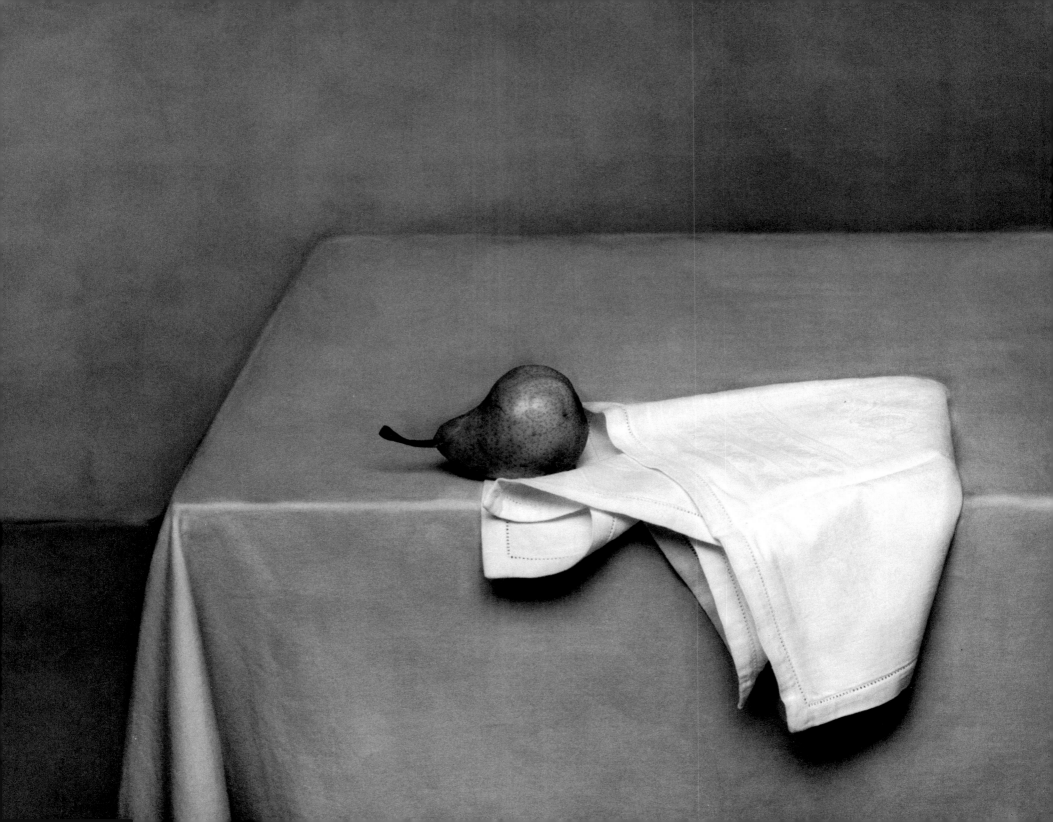

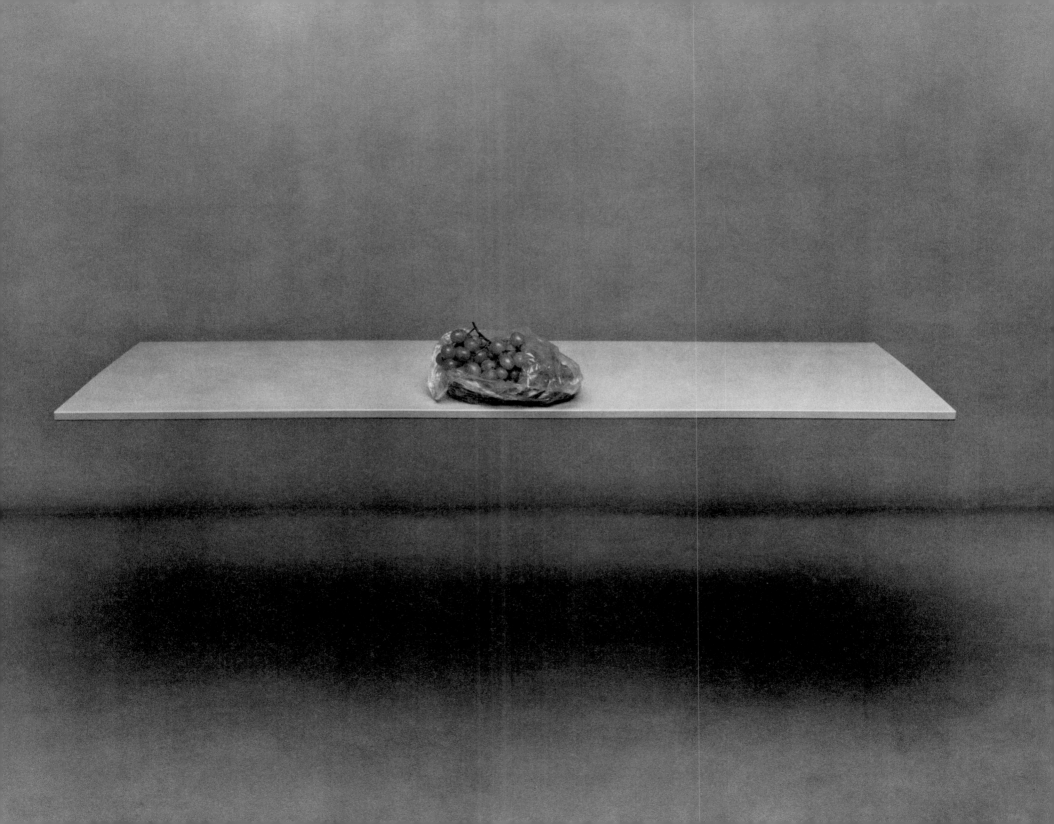

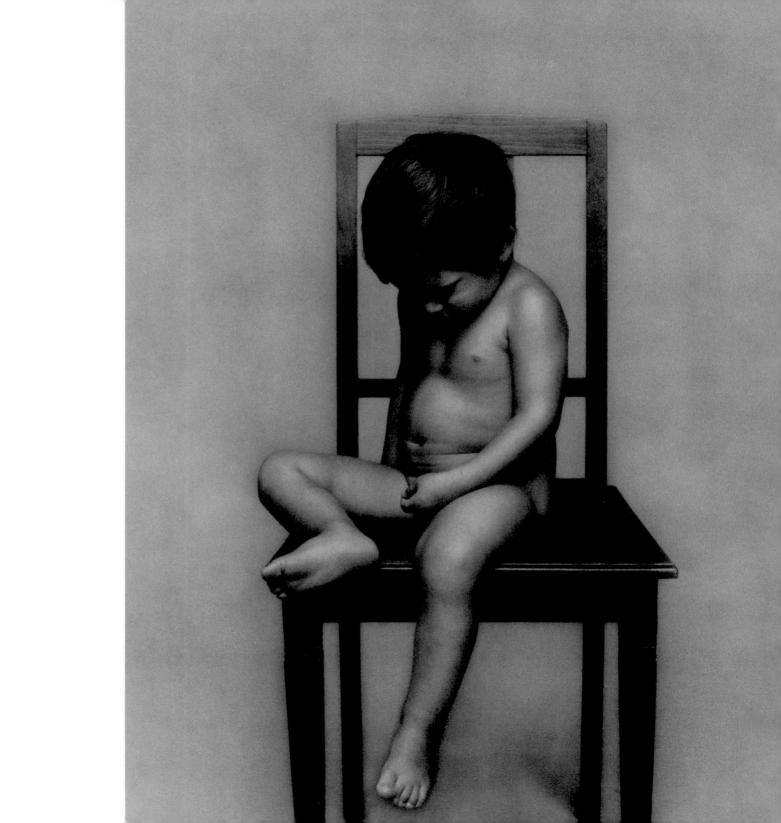

La connaissance (Knowledge), 1996

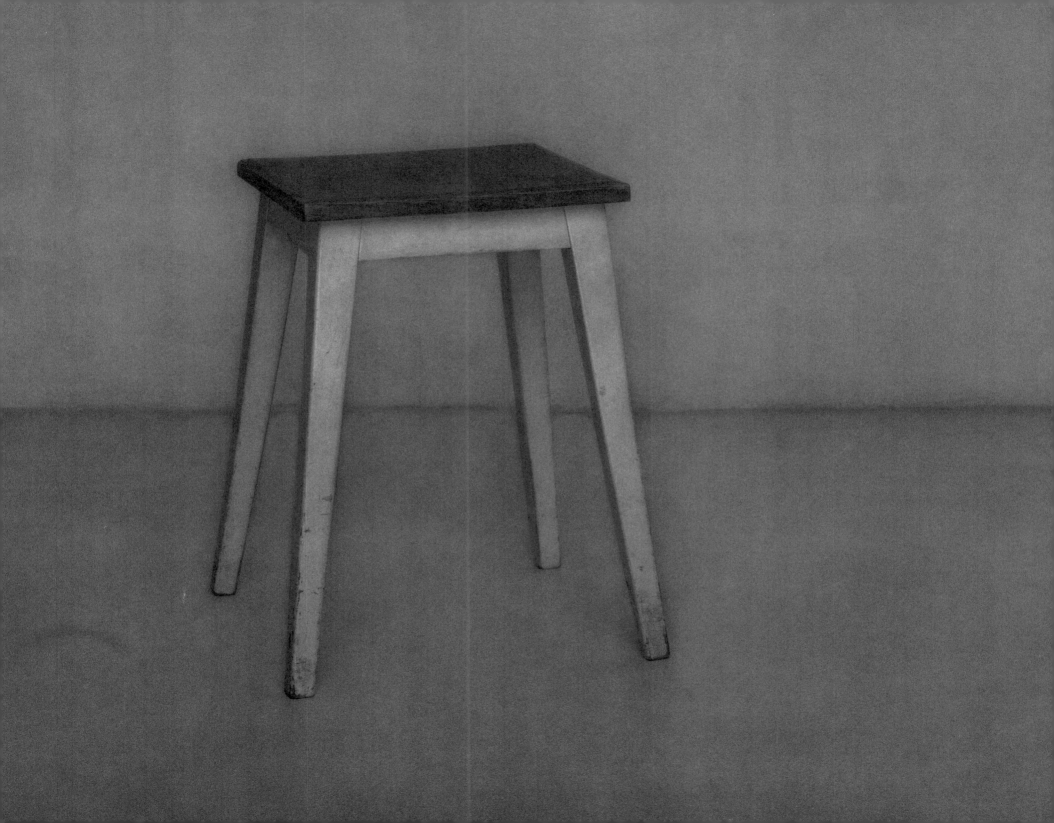

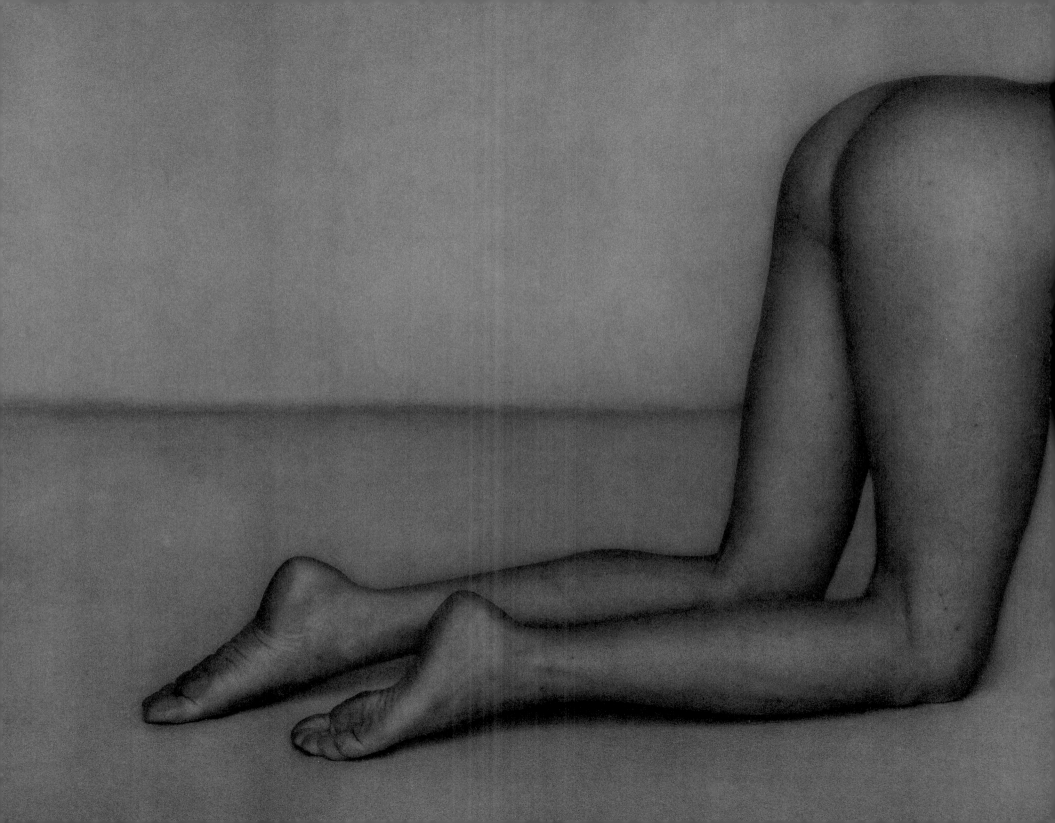

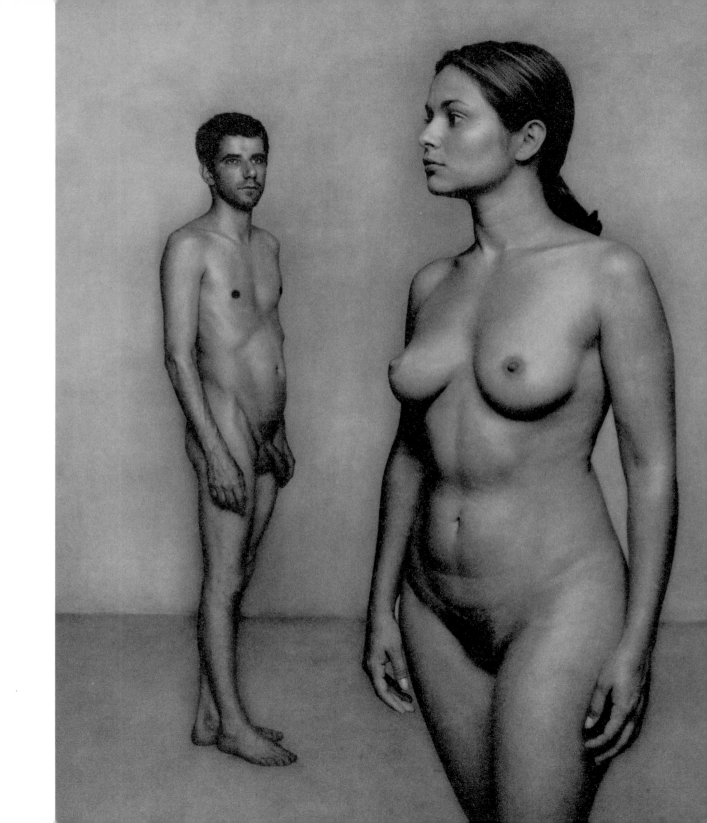

pages précédentes Cécité (Blindness), 1997

pages suivantes

Adam et Ève (Adam and Eve), 1997 L'assomption (The Assumption), 1998 L'homme à son image (The True Image of Man), 1998 Le mépris de Mical (Mical's Scoen) , 1998 Le désarroi de Joseph (Lost Joseph), 1998

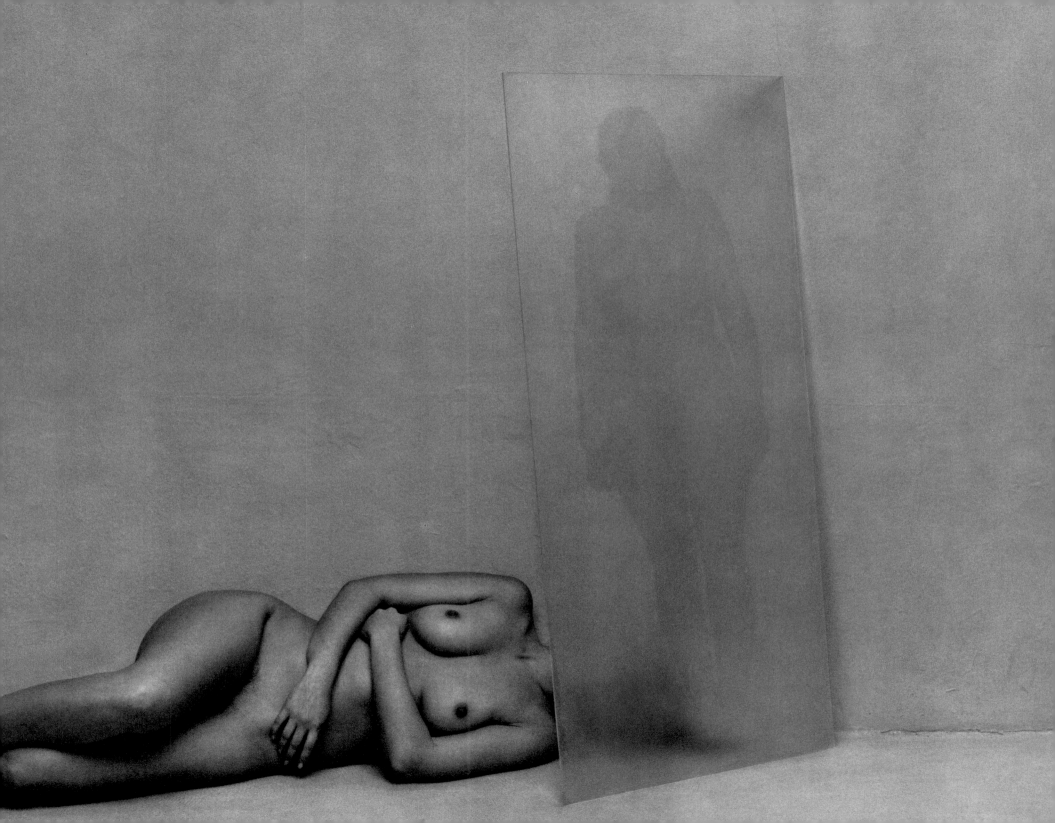

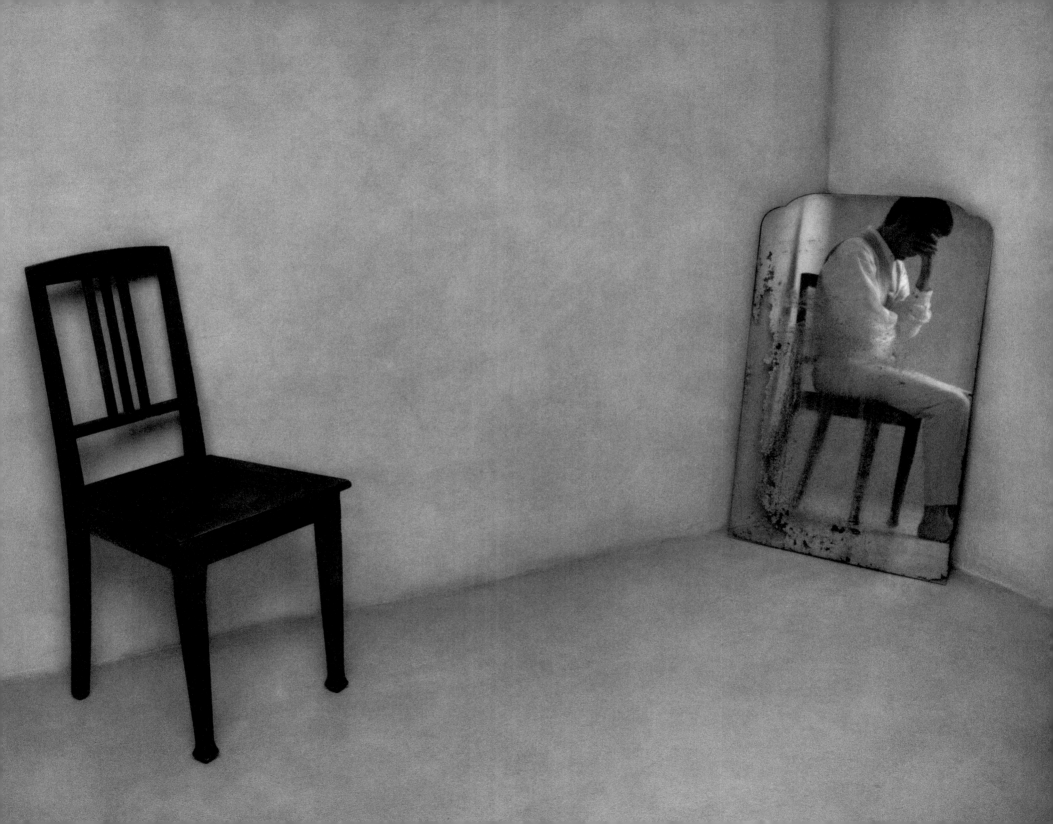

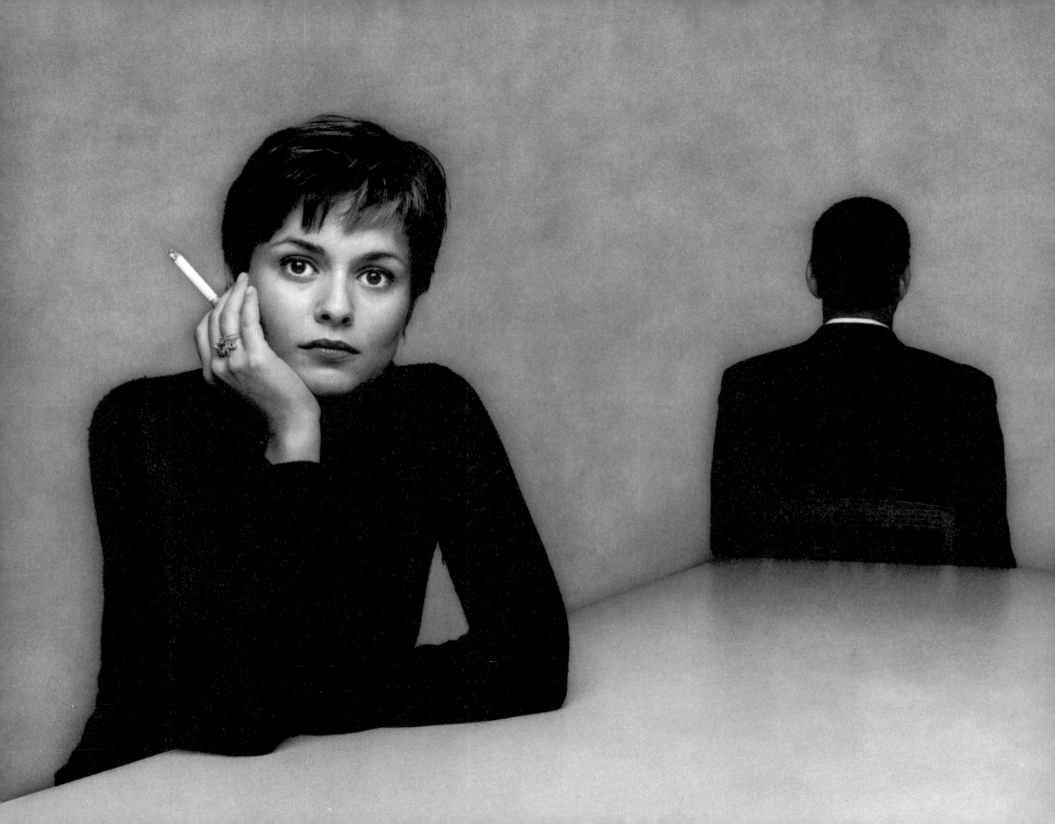

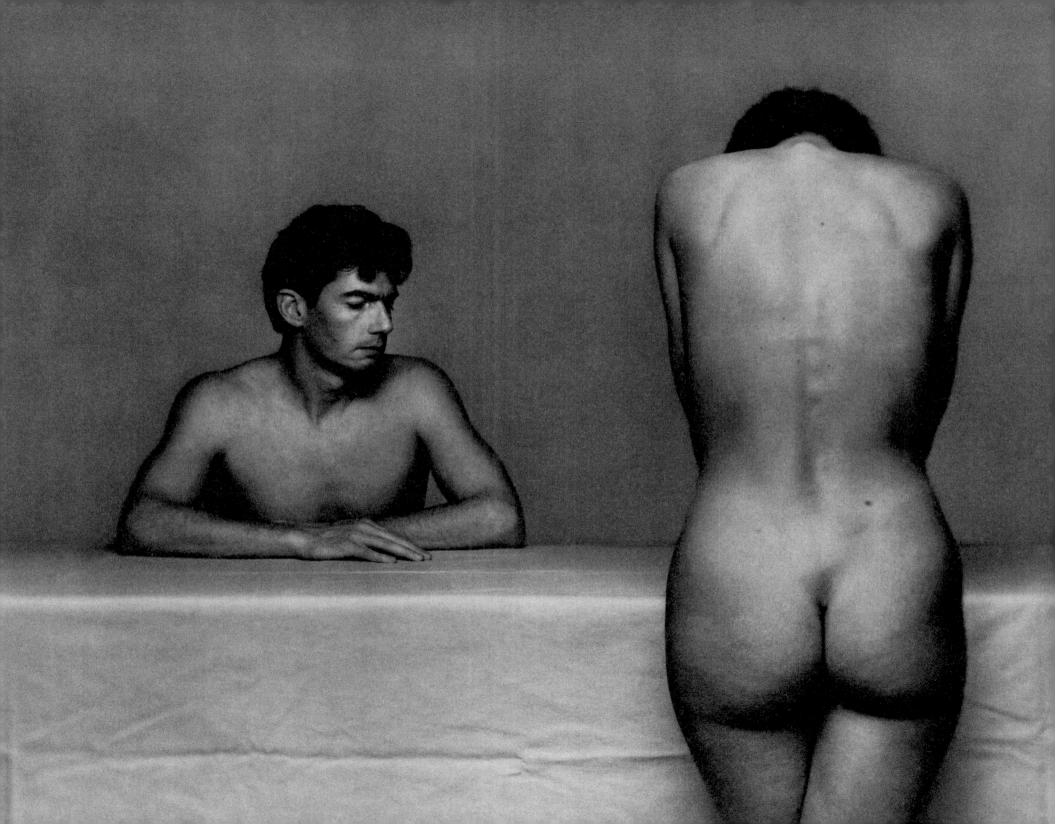

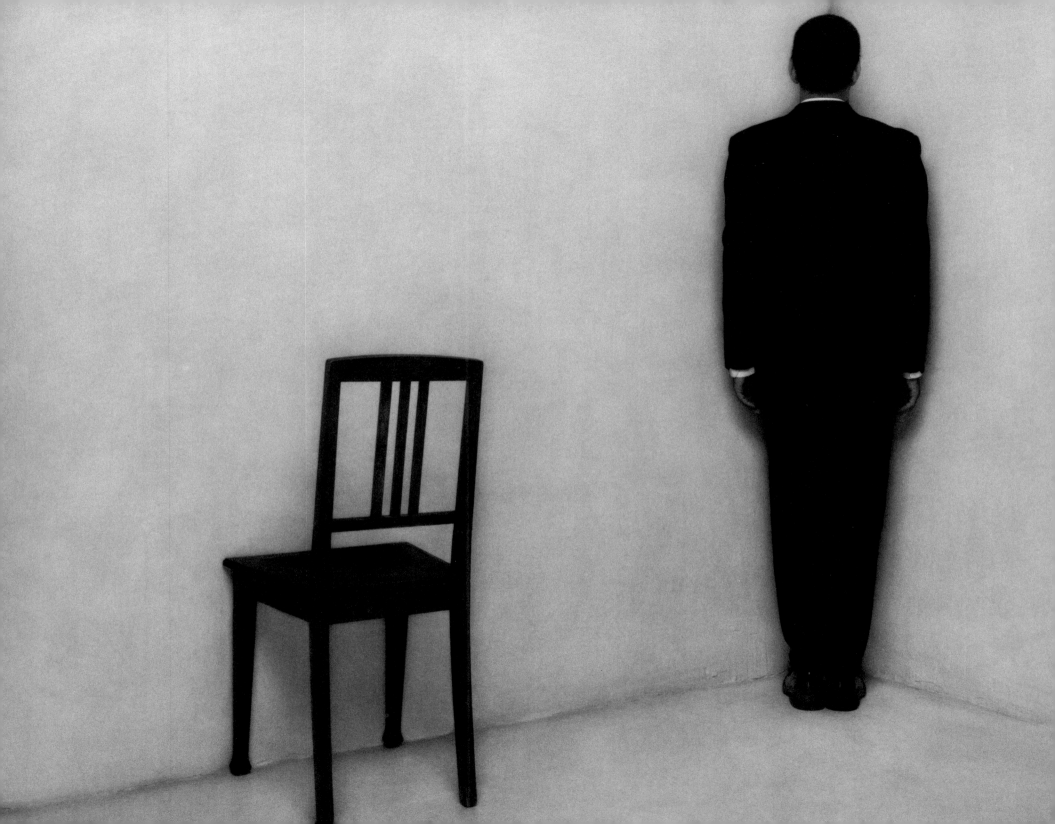

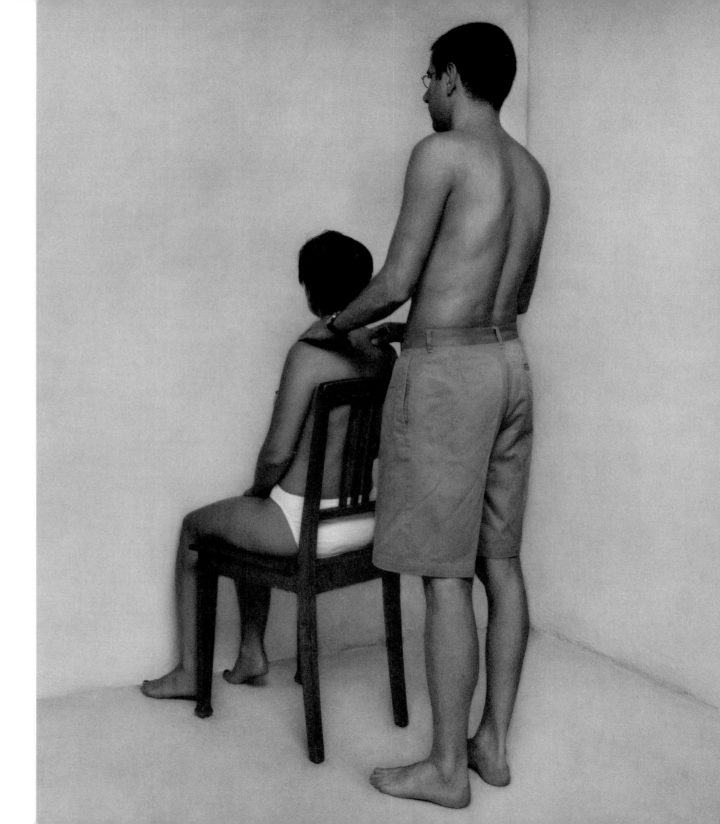

La poursuite du vent
(Chasing the Wind), 1998

Le réconfort
(Comforting), 1998

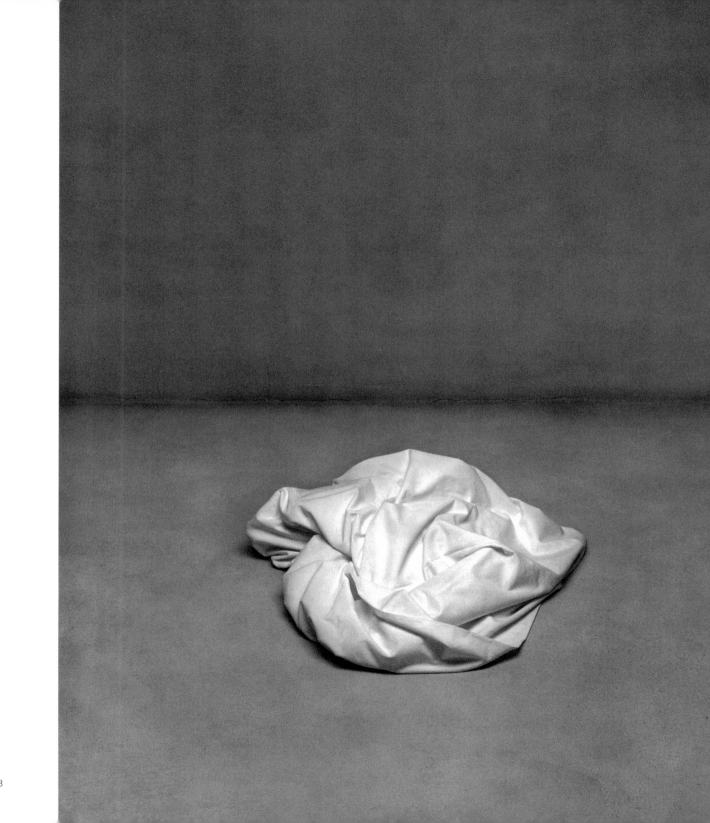

Le linge (Laundry), 1998

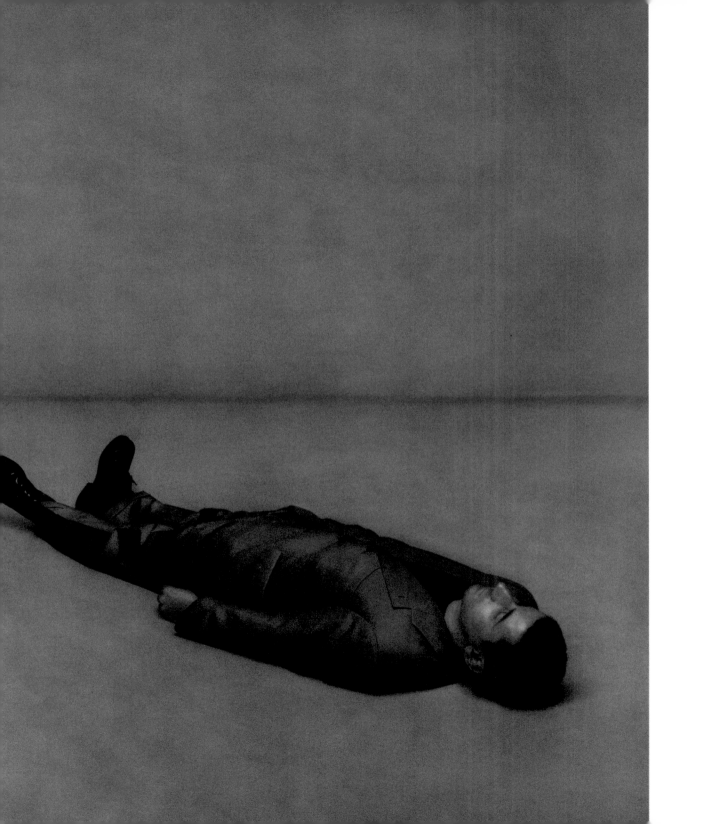

Christ couché (Prostrate Christ), 1998

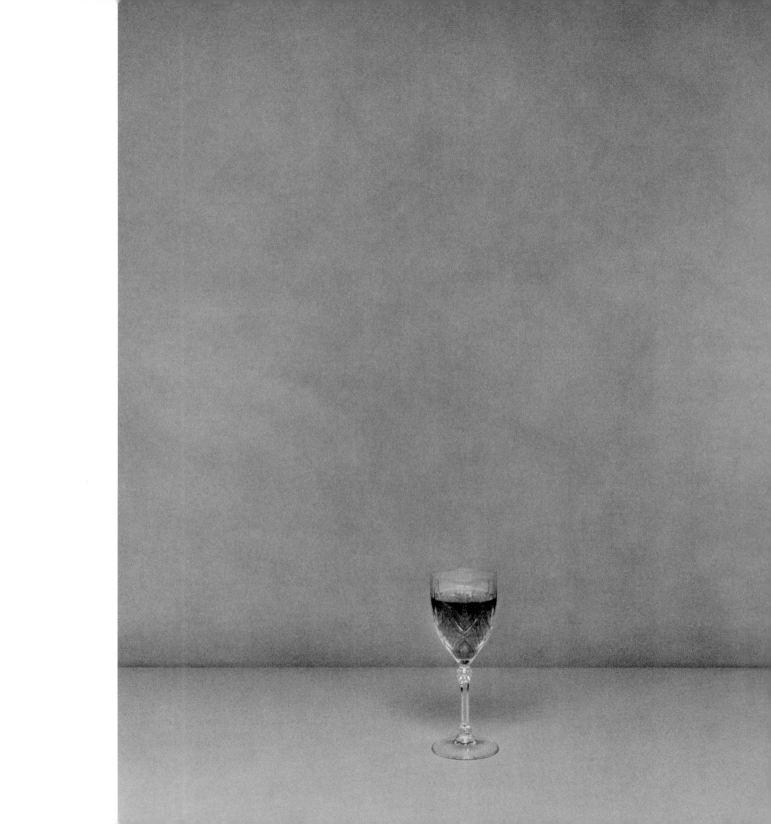

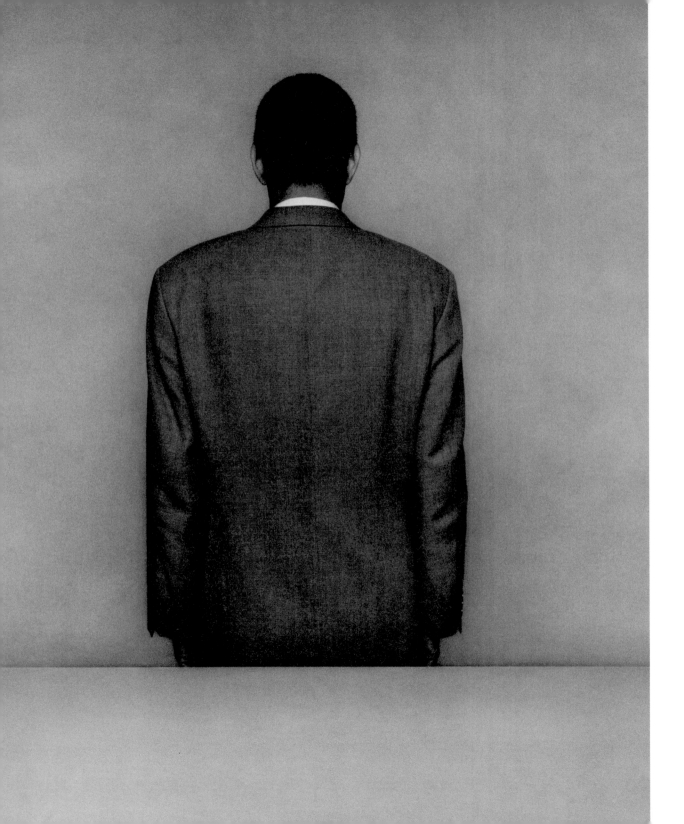

La soif de Dieu (God's Thirst), 1998

Dieu tenté par le hasard (God Tempted by Chance), 1998

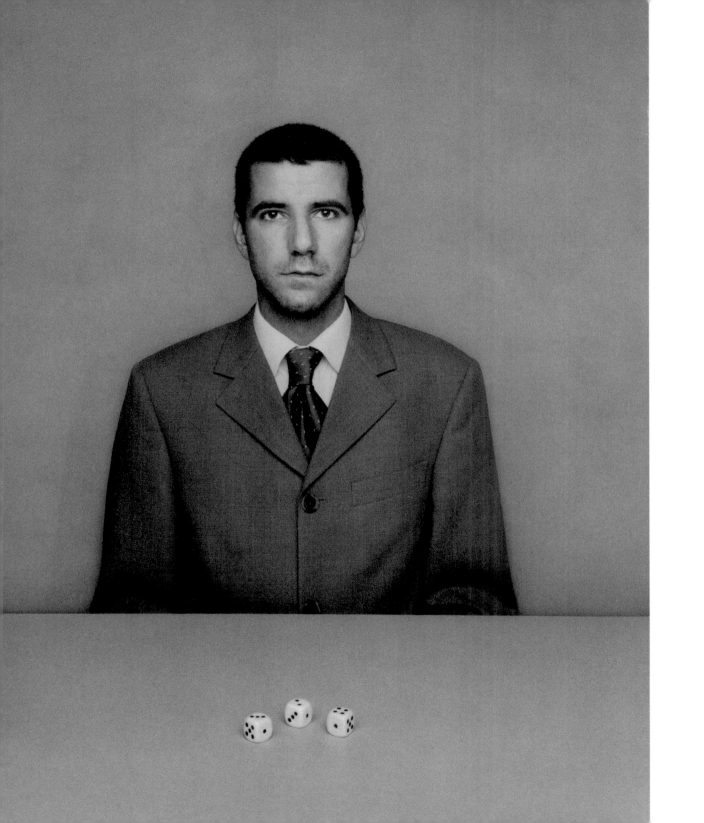

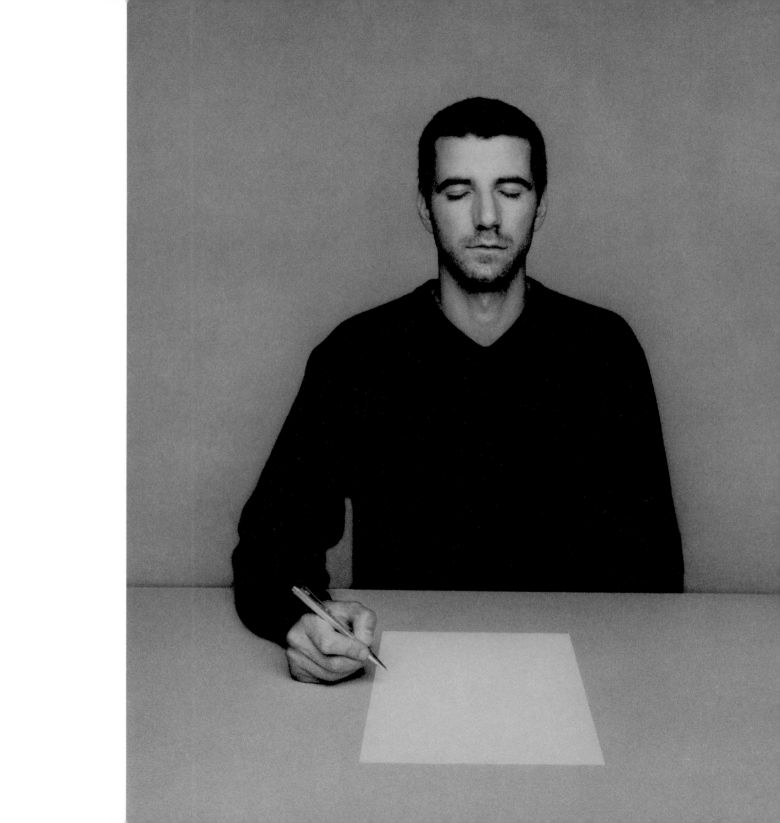

L'auteur (The Author), 1998

L'abolition des mystères (Abolished Mysteries), 1998

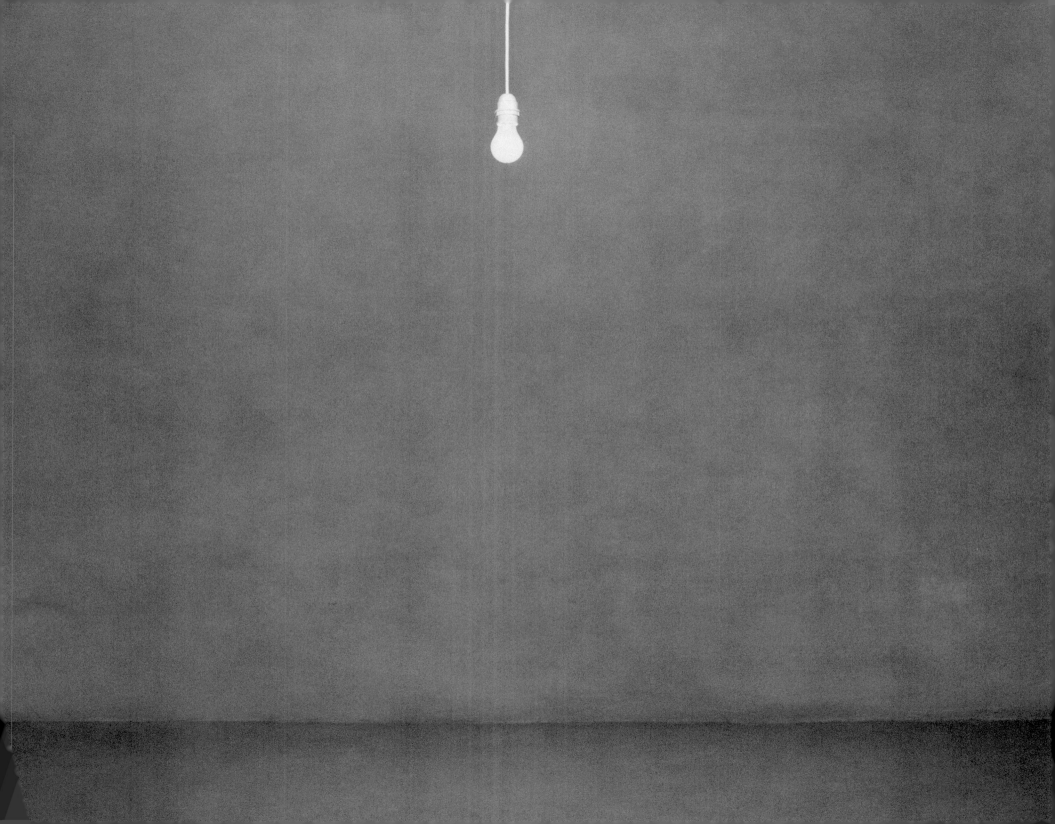

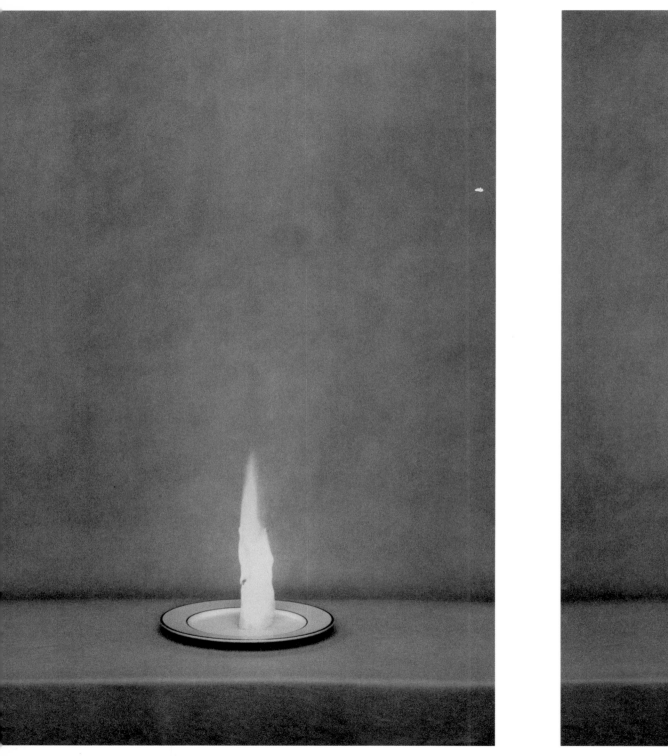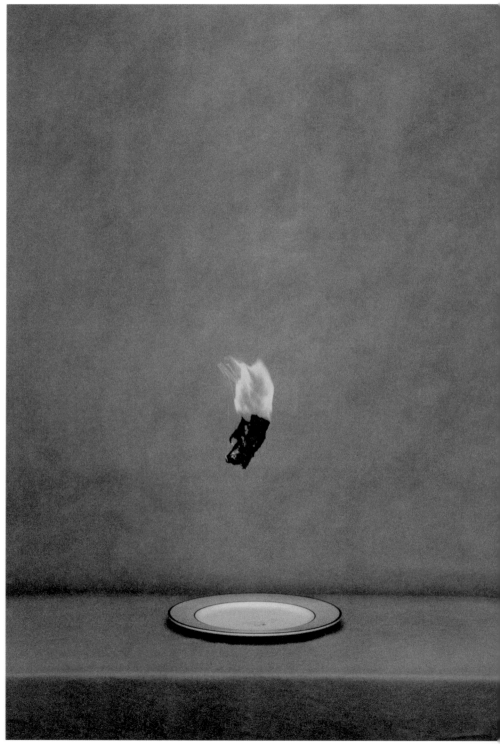

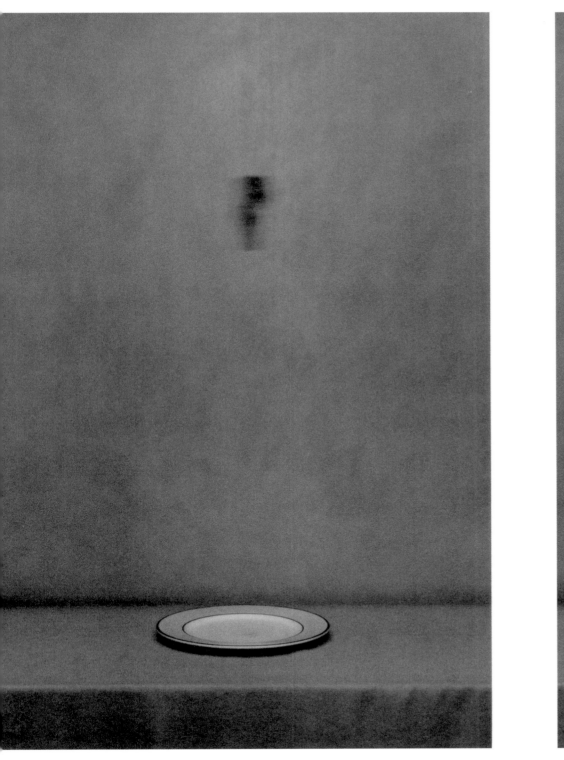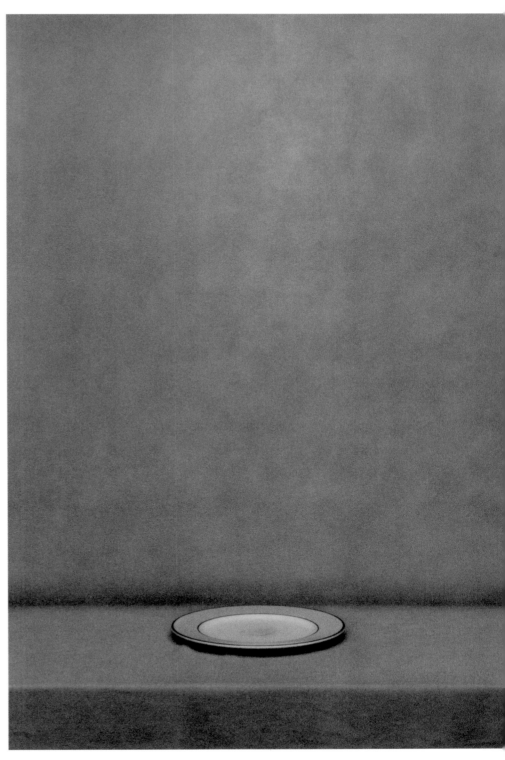

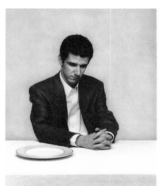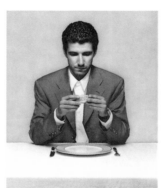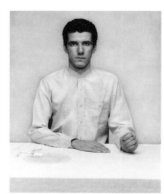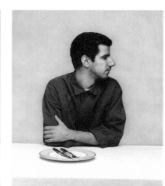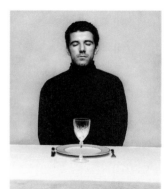

Le repas (The Meal), 1995 **pages précédentes** Transfiguration (Transfiguration), 1995

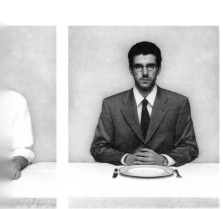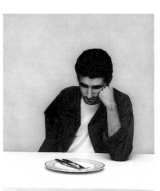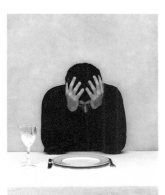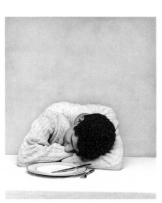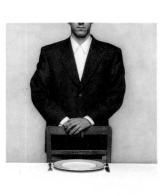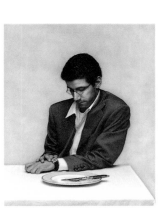

Dieu ne sachant plus que faire de sa toute puissance (God at a Loss to Know How to Use His Power), 1996

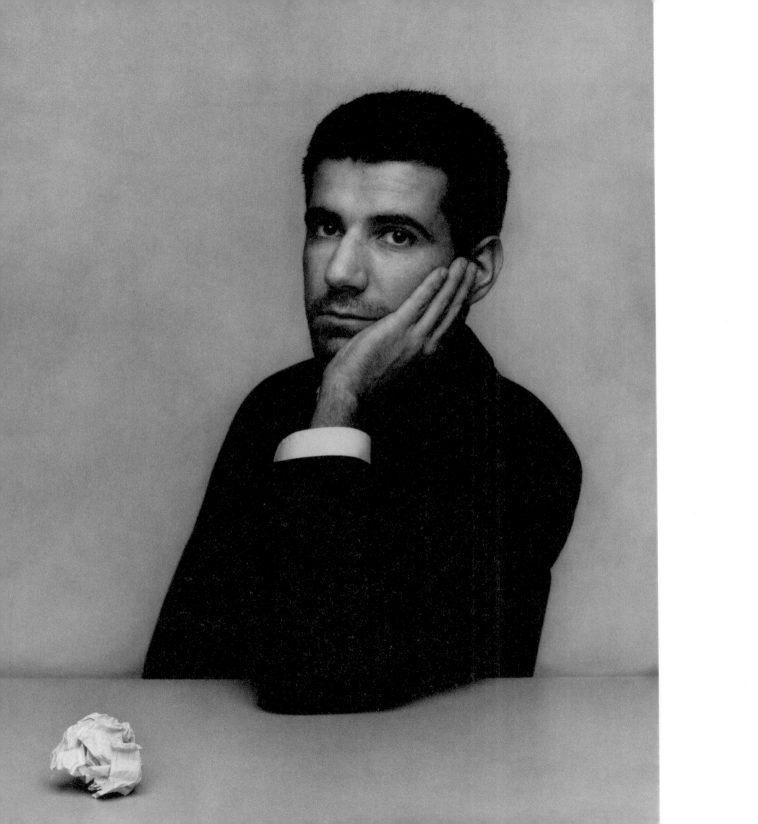

Eden (Eden), 1998

Acknowledgments

Fondation de Famille Sandoz, Pully
Canton de Vaud (DIPC)
Photoforum Pasquart, Bienne

In recognition of their generous
support for the present edition.

As well as

Galleries

Models

Gabriel de Montmollin, Genève
Yves-Marie Marchand, éditions Marval, Paris
Armand Chocron, groupe Vilo, Paris
Philippe Loup, Lausanne
Jean Greset, Galerie Zéro, l'infini, Besançon
Prof. Bernard Reymond, Lausanne
Christophe Blaser, Musée de l'Élysée, Lausanne
Pierre Landolt, Fondation de Famille Sandoz, Pully
M. Siegfried, Photoforum Pasquart, Bienne
Anne Bieler, Lausanne
Iain Watson, Paris

Galerie Zéro, L'infini, Besançon, France
Galerie Knapp, Lausanne, Switzerland
Galerie Lutz Fiebig, Berlin, Germany
Galerie Polaris, Paris, France
Galleria Lipanje Puntin, Trieste, Italy
Galerie Pascal Polar, Brussels, Belgium
Krisal Galerie, Carouge, Switzerland
Galerie Cour Carrée, Nancy, France
Picture Photo Space, Osaka, Japan

Valérie, Marie, Christian, Karin, Alexis, Liliane,
Younouss, Baptiste, Youri, Vanessa, René,
Barbara, Fabian, Myriam & Andrea, Sylvie,
Jade & Pascal.

ISBN 1-58418-020-X Library of Congress Control Number 00-132346
English edition © 2000 Fotofolio 561 Broadway, New York, NY 10012, from the original in French © 2000 Marval.
Images © 2000 Olivier Christinat. Text © 2000 Christophe Blaser and Bernard Reymond.
Concept and design: Philippe Loup (Lausanne). Translated from the French by Marie Guigue and Molly Stevens.
Separations : Sele Offset Torino (Turin). Printing : Musumeci (Val d'Aoste). Printed in Italy.